On Location

Plein Air
Painting
in PASTEL

by Richard McDaniel

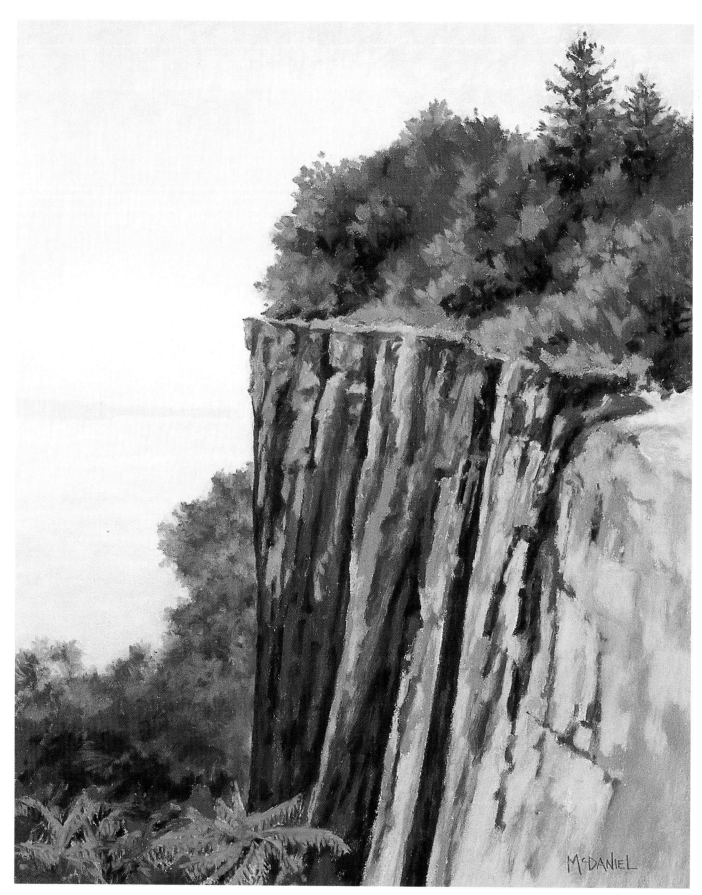

Hudson River Palisades, 14 x 11" (36 x 28cm)

On Location

Plein Air
Painting
in PASTEL

by Richard McDaniel

international
artist

International Artist Publishing, Inc
2775 Old Highway 40
P.O. Box 1450
Verdi, Nevada 89439
Website: www.internationalartist.com

© Richard McDaniel

Edited by Paul Soderberg
Designed by Vincent Miller
Typeset by Cara Herald

ISBN 1-929834-59-4

Printed in Hong Kong
First printed in hardcover 2005
09 08 07 06 05 6 5 4 3 2 1

Distributed to the trade and art markets
in North America by:
North Light Books,
an imprint of F&W Publications, Inc.
4700 East Galbraith Road
Cincinnati, OH 45236
(800) 289-0963

Dedication

To JimBob, my four-legged pal, who
provided silent yet witty commentary
throughout the entire course of this
book's development.

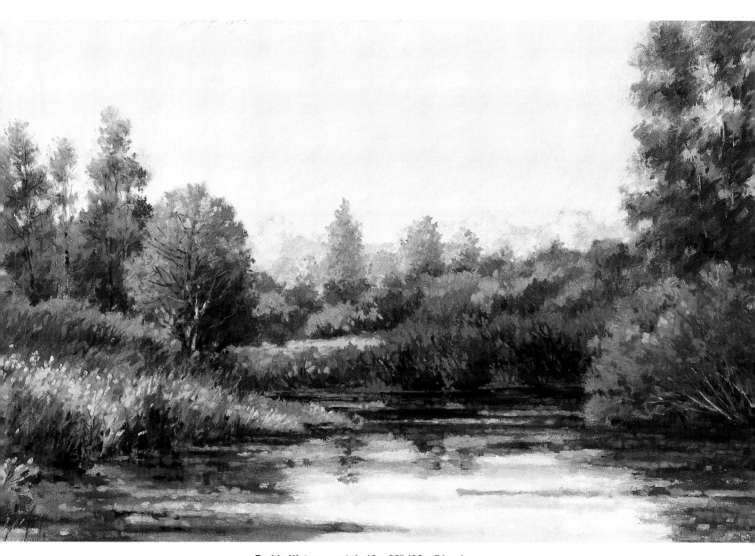

Ruddy Waters, pastel, 12 x 20" (30 x 51cm)

Contents

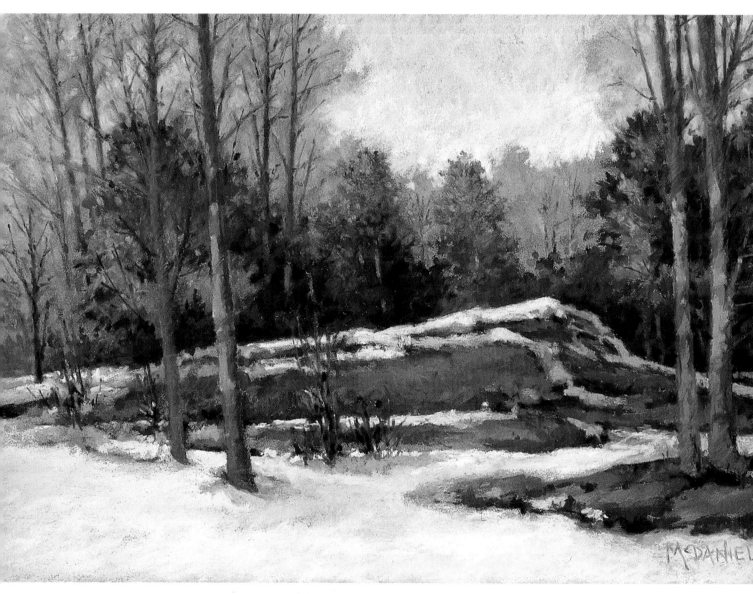

Winter Ledge, 10 x 15" (25 x 38cm)

Foreword

My good friend Richard McDaniel and I have a long history, and I fully agreed when *International Artist* magazine called him both a "master painter of the world" and a "master pastel artist of the world." Now, with International Artist Publishing's decision to publish this book, I am delighted and honored to be able to say a few words about him and his work in this Foreword.

Not only did Richard and I teach at the same school in New York, the Woodstock School of Art, but since then we have traveled similar artistic paths. It was 30-some years ago, there in Woodstock, that I decided to take my pastels outdoors and to paint plein air. It was much the same for Richard, who was still working exclusively in oils but soon began to experiment with pastels.

Only a few other artists had tried this endeavor and there was a great deal of effort and experimentation to figure out just how to arrange to paint with pastels, in full color, on location. Now this wonderful book, *On Location*, devoted to painting plein air with pastels, shows how far individual artists like Richard and our entire profession have progressed. Plein air pastel painting is no longer a revolutionary concept. And the fact that it has "arrived" is due largely to the efforts of a handful of dedicated artists, including Richard McDaniel. Knowing him personally, his work professionally, and above all his thoroughness and teaching excellence, I am delighted by the publication of this book, which will dramatically continue the trend toward pastel painting being viewed as a superlative medium worldwide.

Painting on location with pastel is unique and special, and there is no better way to get into it than by learning the secrets of those who have paved the way. For that reason, I highly recommend this book to anyone who wants to paint on location with pastels, and to anyone, whether beginning art student or professional artist, who is interested in reading the thoughts of a true master of the medium.

— *Albert Handell*

Editor's Note: In 1987 Albert Handell became one of only three living artists ever elected by the Pastel Society of America to the Pastel Hall of Fame. In 2000, together with Anita Louise West, Albert Handell wrote *Painting the Landscape in Pastel* (Watson-Guptill Publications, New York, 2000.) The same year he received the first Lifetime Achievement Award for Pastel ever presented by the Pastel Society of the West Coast.

Introduction

Throughout history, oils and watercolors have been the primary painting media for plein air work. Drawing has also been eternally used by artists who have trudged out into the fields to record their observations of nature's majesty. In this book we'll examine pastel, and its increasing use as a medium for outdoor painting.

Pastel is ideally suited for outdoor landscape work. With a full range of vibrant colors and a wide variety of application methods, a pastelist is able to respond quickly to the many bold and subtle moods of nature. Its versatility as both a drawing and a painting medium allows for a rapidly applied image, in full color, to be left as a sketch or further developed into a painting, using the same materials throughout.

Most of the pastelists I know have also worked in oil and/or watercolor. Similarly most plein air painters I know work in the studio as well. These approaches are not mutually exclusive, and an artist often benefits from the cumulative knowledge that comes from exploring all disciplines. It is equally true that all forms of outdoor painting have merit, whether it is the completed painting, the sketch, the study, the half-completed piece, or the so-called failure.

Observation is one of the most critical elements of learning to paint nature effectively. As long as an artist is increasing his or her skills of observation, really learning to see, then all outdoor drawing and painting excursions are worthwhile. The value of working *en plein air* is infinite, whether you produce finished pieces in the field or not. All artists will profit from the time spent learning directly from nature — exploring, investigating, interpreting, and painting on location.

Landscape painters feel a strong spiritual connection to the environment, and often work for socio-environmental causes. Some even donate a portion of their income to benefit the preservation of the land. Scholars have long noted that the ecology movement has roots in the efforts of the Barbizon artists to prevent the deforestation of the Fontainbleau area. Recently artists have been participating in worldwide paint-outs, gathering in various locations around the globe to paint publicly on a specified day, such as September 11th.

All in all, plein air events are great opportunities to visit with and work next to your peers. These events also offer a wonderful chance for those interested in plein air painting to see experienced professionals as well as enthusiastic amateurs in action.

One thing about painting — the craft is so long to learn, and we all continue to learn our whole lives. Painters learn from painters then teach other painters who in turn teach others. I have seen artists at plein air events whose work I have admired for years. We're all trying to improve. It is wise to remember Michelangelo's motto, even when he was in his late 80s: "I'm still learning."

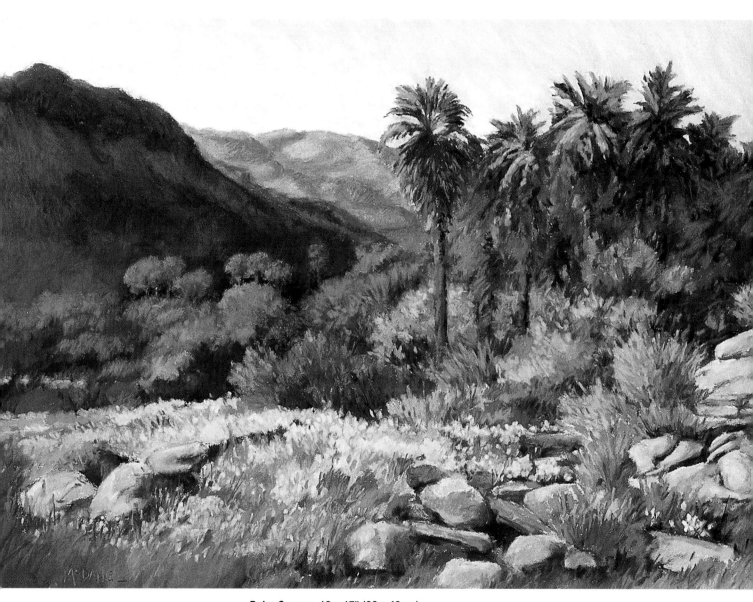

Palm Canyon, 12 x 17" (30 x 42cm)

The Plein Air Experience

Once upon a time an artist set up his easel in a grassy field and began painting the peaceful valley he saw before him. An hour later he was busily at work, thoroughly absorbed in his task and whistling a tune, when a well-dressed businessman strolled up and stopped. Maintaining a respectful distance, the gentleman observed for several minutes. "Hello," he then said pleasantly, "I've been watching you work for a few minutes, and that is a remarkably good painting. Do you do this for a living?"

"Yes," the artist replied.

"Oh wonderful. You certainly seem to take your work seriously. May I ask you, and I mean no disrespect, but how much money do you make in a normal year?"

To this the artist stood up and proudly said, "Twenty thousand."

"Very good. A hundred and twenty thousand is quite a good living."

"No," the artist replied, "you heard me wrong. I said *twenty* thousand."

"I heard you just fine," the gentleman said with a smile, "I added an extra hundred thousand for the quality of your life."

I have often shared this story with my students at painting workshops. It beautifully illustrates something that I know to be true from my own experience: the life of an artist is worth far more than the money we earn from our work.

This is valid throughout the spectrum of artistic disciplines, but I feel it is especially so for the artist working out in nature, *On Location*. To be honest, part of the appeal is due to our romanticized view of the Impressionists and other

The author in the garden at Matanzas Creek

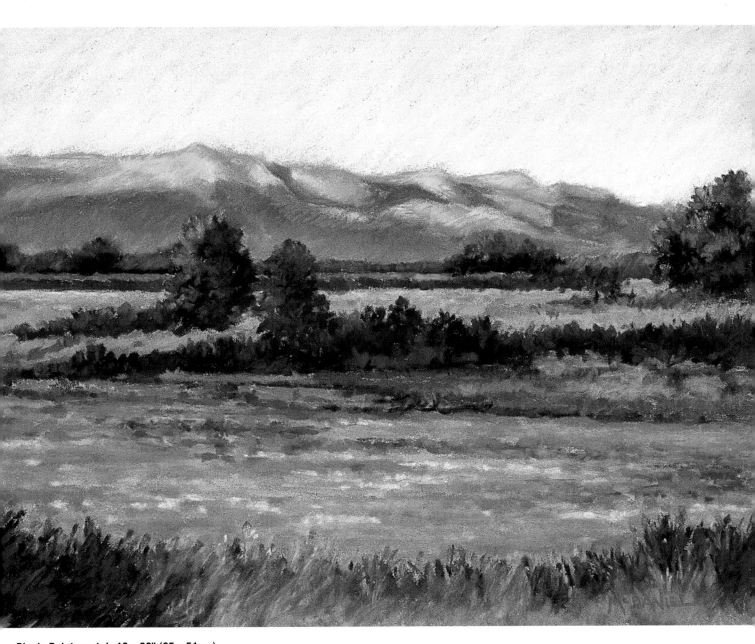

***Picnic Point**, pastel, 10 x 20" (25 x 51cm)*
This is the view from one of my favorite picnic spots. The day is coming to a close and it's time to pitch a tent or head on home. Knowing that the scene in late afternoon light could be superb, I set up my easel a few hours after lunch and established the major shapes of the painting before the poetic lighting began to appear.

Richard McDaniel in lavender

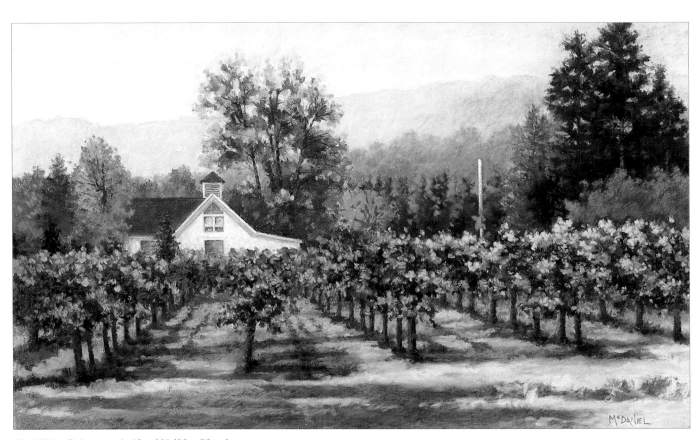
***The White Pole**, pastel, 13 x 23" (33 x 58cm)*
Luckily I live close to several vineyards. I can easily return day after day for extended plein air sessions. For this piece I spent the first day concentrating on proportions and perspective. Toward the end of the next day, a ray of sunlight illuminated the pole, turning it from a pale gray to a gleaming white.

Yellow Wedge of Spring, pastel, 4 x 6" (10 x 16cm)

Pastel works well for the quick sketch. Here are four examples of the "little gems" I enjoy painting on location. I use a small selection of pastels and a lightweight easel. Everything fits easily into a daypack.

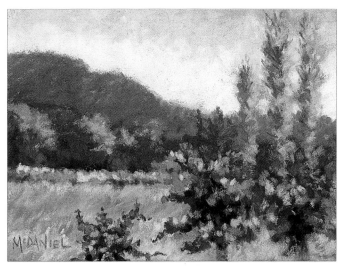

Vineyard Poplars, pastel, 4 x 6" (10 x 16cm)

Chicken Shacks, pastel, 4 x 6" (10 x 16cm)

Looking in from the Beach, pastel, 4 x 7" (10 x 19cm)

"The conditions may be harsh, and the task may be hefty, but ahhhhh, the reward. Working from life makes you a stronger painter, and painting from life in the open air makes you come alive!"

Orangeluma,
pastel, 13 x 18" (33 x 46cm)
I was driving home from Petaluma and saw a field of orange flowers. I don't know what kind of flower they are. I just stopped and painted what I saw.

Solo vs. social

One of the main contrasts between artists and musicians is that art-making is usually a solitary pursuit. We work alone at our craft like a writer or inventor, creating and editing until we have a product ready to present. True, musicians, actors and dancers may rehearse in private, but their real product, their performance, is created in front of others. That performance is by its nature more social. Painters connect with people, but usually they do so outside the work environment.

Sometimes it gets lonely, working away at the easel day after day. It can also get far too comfortable in the studio. It's easy to surround yourself with creature comforts, lose yourself in your work, and act like a hermit.

Painting on location is an excellent way to be more social, though that is far from its main purpose. Heading out for some plein air painting with a few buddies gets you safely out into the world, ready for the unexpected. It also provides you with a network of kindred spirits that can offer encouragement, advice, or motivation. And sometimes it's just a real treat to talk with other artists about art.

If you go out alone, you might run into strangers, but with a group you'll have the additional interaction of planning, traveling to and from the site, talking during breaks, and the shared reward of packing up and heading home at the end of a hard day's day.

But how do you get started? Sometimes inertia is difficult to overcome, and "going out to paint" may be easier said than done. For some it is hard enough to get started in the comfort of their own studio where they can struggle in private with nobody looking on. It may require an enormous effort to assemble gear and head out into the landscape — especially if one is uncertain.

Not knowing how can be quite a weight around your ankle. And this uncomfortable condition is amplified in public. But knowing always starts from a position of not knowing, then we learn, and then we know. Aristotle put it best when he said, "What we have to learn to do, we learn by doing."

To learn by doing, yes, that is good. But a little guidance can certainly streamline the process. If you want to expand your learning, and save time in the bargain, try a plein air workshop. The programs usually last a week and are wonderfully intense, with an opportunity to paint day after day after day with a professional instructor and a small group of other artists.

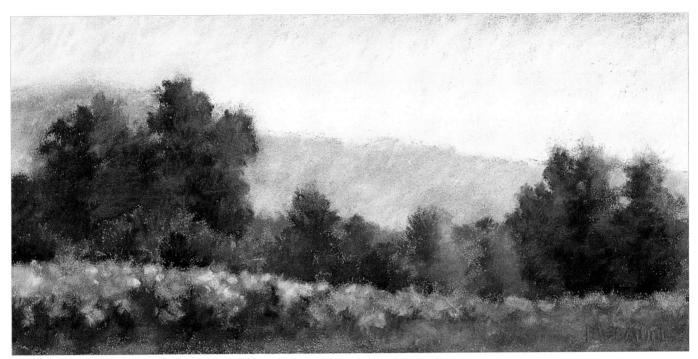

Glory in the Morning, 4 x 10" (10 x 25cm)
One morning at Sonoma Plein Air a number of us gathered at a vineyard estate and painted in all directions of the compass. I chose to look East as the sun was just burning off the early morning haze. The hill in the background, though not far distant, revealed no detail. Its flat cool color created a quiet backdrop to the sunlit foreground.

artists who struggled so mightily for the acceptance of their work. Our nostalgia for a seemingly simpler time may make us eager to join the ranks of previous artists who worked directly from the landscape. But that certainly is not all.

There are additional magnets that pull us outdoors. One is the call of our muse, Painting; another is a love for Nature herself; and yet another is the challenge of working outdoors, *en plein air*, in front of *le motif.*

While the art of painting is reason enough to work day after day, under whatever conditions we deem necessary to our task, this devotion is universal to all artists, including those who slave away in studios. Though the desire to unravel the mysteries of art is always a part of a landscape painter's *raison d'etre,* it is not our exclusive purpose for heading outdoors.

A love of Nature is a sentiment that is common to most landscape painters but this alone does not make a plein air painter, for there are legions of hikers, campers, bird watchers, and naturalists who truly enjoy their time in the field, yet do not paint. However, while many artists may love nature (think of the thousands who walk in the woods, take a photograph, and work in the studio), a plein air painter works *within* nature. He or she accepts the challenge of

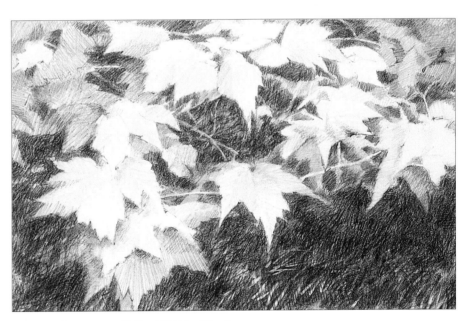

The Leaf Cluster, pencil, 7 x 11" (18 x 28cm)
You don't have to travel far to find a suitable motif. These leaves were just outside my studio door, and their pattern caught my interest. Whether I work in pencil, oil, or pastel, the first step is finding an intriguing composition, regardless of subject.

Mont Ste. Victoire, pencil, 6 x 9" (16 x 23cm)

The drawing in my sketchbook has promise, but I don't like the way the tops of the trees echo the slope of the mountain. I drew them as they were, but the more I looked, the more I wanted to alter their contour.

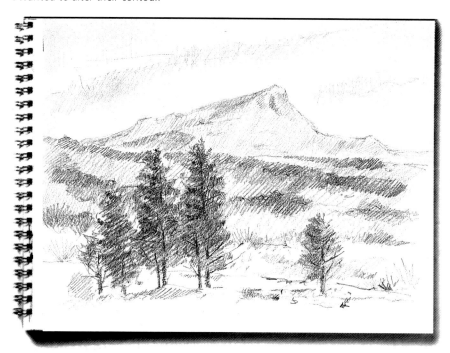

painting changing light and unpredictable weather in order to connect more intimately with the subject. The conditions may be harsh, and the task may be hefty, but ahhhhh, the reward. Working from life makes you a stronger painter, and painting from life in the open air makes you come alive!

I've been carting my easel out into the field for years, exploring the wonders of landscape painting. My experiences have been varied, from exhilarating to frustrating, but always intense. Working on location inevitably adds to my understanding of the landscape, whether I come back with a completed painting or a preliminary drawing. For this reason I want to embrace all forms of outdoor work, from quick sketches to sustained studies, from paintings completed on-site to those that retreat to the studio, either for further work or to serve as reference material for new pieces.

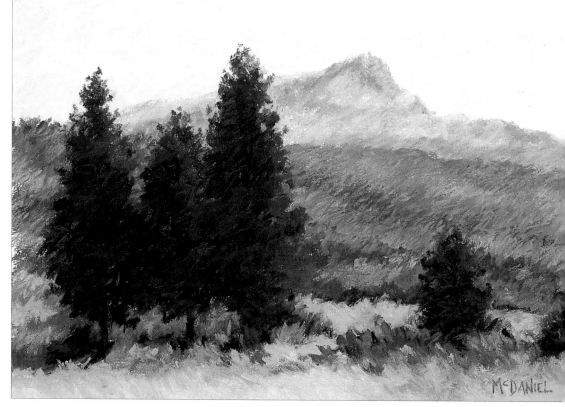

Mont Ste. Victoire,
pastel,
8 x 11" (20 x 28cm)

I decided to lower the center tree and to change my vantage point so that the tops of the trees broke into the sky. This decreased the majestic quality of the mountain somewhat, but also helped integrate the various components of the design.

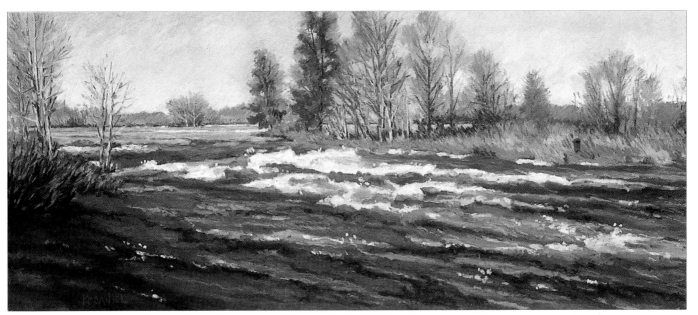

Riparian Race, 8 x 20" (20 x 51cm)

Moving water is amazing. It is always moving yet it is remarkably constant in its form. After blocking-in the basic shapes of the water, I painted most of the background and returned later to paint the foreground. To render moving water, I look at the subject for a split second and paint a few strokes. Then I look at the water again and paint a few more strokes, even though the individual waves have moved on. The end result is a record of the water as it looked over the course of many glances. It is a composite view, yet is true to the overall feeling of the river.

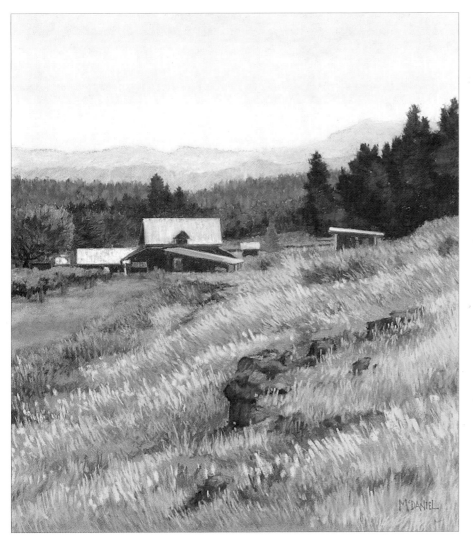

Blue Rock Farm,
pastel, 15 x 13" (38 x 33cm)

This farm is not far from my home so I have the luxury of revisiting the site and painting the scene over a few sessions. On the first day I emphasized the yellowness of the sky because it was the best color to suggest the summer heat. Thereafter I keyed the rest of the composition to the light of the sky.

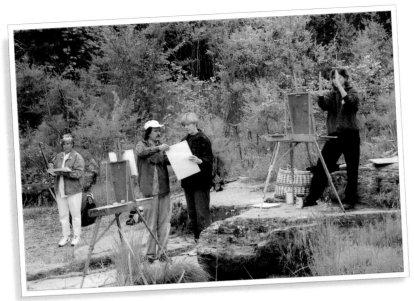

Here is a workshop class getting ready to paint along Santa Rosa Creek.

Plein air painting
Authentic plein air painting can be described as artwork *done from life, on location*. It is begun on-site and substantially completed in front of the subject. Minor adjustments may be made back in the studio, but never so much as to alter the character of the painting. No determination is made regarding how rough or how polished the painting should appear. Plein air painting, just like studio painting, can run the entire range from realism to abstraction.

The artwork is often finished in one session, although it is perfectly acceptable to return to the site repeatedly until the work is complete. Such a method is often called "extended plein air" or "sustained plein air," and is usually employed for large

Workshops and painting groups

Lectures and demonstrations are common, but the greatest learning results from each artist working at his or her own easel, with periodic guidance from the instructor. Group discussions and critiques commonly round out the week, usually with lots of fun and relaxed kidding around. You may work with painters who are fairly accomplished and are trying to refine their skills (we never stop learning). Other participants may be less advanced but eager to improve. There is an enormous amount of learning that comes from sharing ideas with other painters. A good instructor will promote this interaction by creating a positive environment for working.

If you've never tried a workshop, I highly recommend that you do so. It is certainly one of the best ways to grow as an artist. Workshops are designed around specific topics, concentrating on the "nuts and bolts" information so important to painters. In addition, the camaraderie can be tremendous and many long-term friendships develop out of a workshop setting.

A local workshop has the advantage of minimal travel and lodging expense, and none of the headaches of packing and making travel arrangements. However, you must make arrangements with yourself to dedicate a solid week to the class, rather than "fitting it in" around your normal daily activities.

Generally an "away" workshop provides you with the most intense experience. Plein air workshops are frequently held in scenic locations, so the new environment may have a fresh impact upon your aesthetic psyche. You may focus more on your art; you might even continue to paint after class has ended for the day. Quite likely you will go out to dinner with some of the other artists and talk all evening about painting. At the end of the week you'll be exhausted, but happy. After you return home you'll be fueled by enduring memories. Information you learned in the class will last for years.

The formation of a painting group is often the outgrowth of a successful workshop. Painters make new friends and develop a rapport with fellow students who want to continue the plein air experience after the instructor has gone. As with many activities, a little instruction can go a long way, then it's practice-practice-practice until more instruction can be absorbed. A painting group provides just enough structure by specifying a time and place to paint, and perhaps an informal critique, but mostly it provides you with incentive to get out and paint.

Whether you join a class or join a group or go out informally with friends, take advantage of the companionship offered by painting with other artists. It's as much fun as joining a figure drawing group, except that you get to go outside.

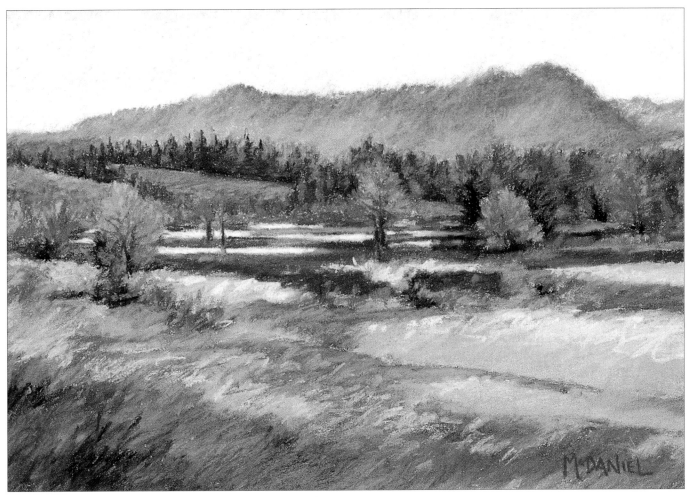

Vernal Pools, Laguna de Santa Rosa, pastel, 8 x 12" (20 x 30cm)
The laguna is punctuated by many temporary pools of water in the Spring. Several of us assembled at Stone Farm for the day to paint the barns and fields. I found a spot to work on a little knoll overlooking the laguna.

Springtime delivers a carpet of bright yellow for the Laguna Painters. Note the modified golf cart. Its large wheels have absolutely no problem with a gravel road.

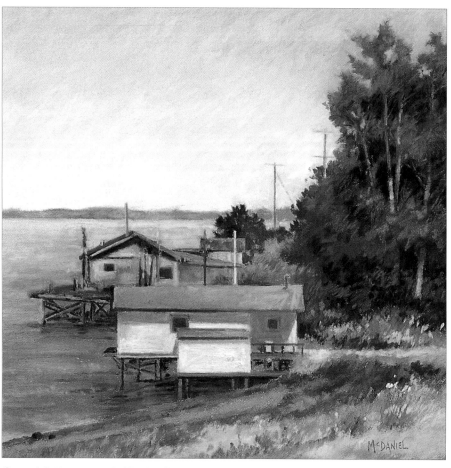

Coastal Cottage, pastel, 12 x 12" (30 x 30cm)

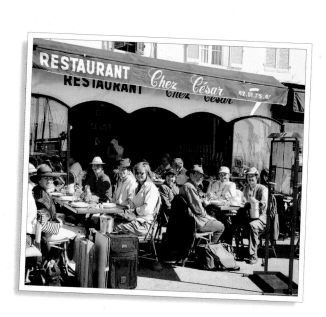

or complex compositions. Monet frequently worked in this fashion, often setting up several canvases, and switching to a new one as the light progressed through the day. The next day he'd apply a second layer of pigment to each painting during the appropriate light period, continuing for as many days as needed to complete them all.

Pure plein air painting, as defined above, is an incredible experience. The very hardships of working outdoors that are so bothersome are also beneficial, for you are forced to focus on what is essential to the process of painting. You are encouraged to become more effective in your observation of the motif, in your plan of the composition, and in your execution of the artwork.

However, the complete outdoor landscape experience is broader and more inclusive than *alla prima* painting on-site. While the rapid plein air approach is to be greatly admired, there is ample room for other valid experiences on location. The longtime system of sketching in the field and then working in the studio should not be thrown out with the bath water. Sketching on location puts you directly in front of the subject and fosters your intimate connection with nature. Plein air drawing shouldn't be overlooked in the discussion, relegated to the role of a *preliminary* action. Many plein air drawings are superb in their portrayal of light effects and landscape form.

During this class in France, we all took our midday meal at an outdoor café in the seaside village of Cassis. After painting all morning, and anticipating more work in the afternoon, we thoroughly enjoyed our well-deserved noontime break.

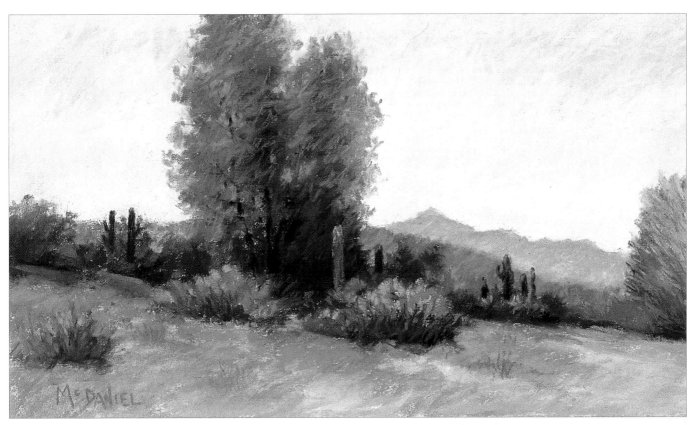

Desert Afternoon (The Pickles of Papago Park), pastel, 9 x 12" (23 x 30cm)
One of the marvelous benefits of teaching landscape painting workshops is that they are usually held in scenic locations. I get to see a great variety of topographical features. This is a demonstration painting I created for a class in Scottsdale, Arizona. When the week was over, I packed up the piece (as described on page 57) and brought it safely home.

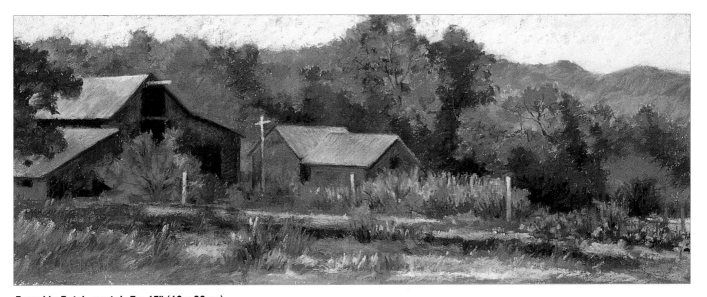

Pumpkin Patch, pastel, 7 x 15" (18 x 38cm)
I started painting the pumpkins up close but discovered that I kept looking up at the buildings and the surrounding landscape. I simply went with my instinct and backed up for a more distant view. Besides, the sun was too hot and I needed to move into the shade.

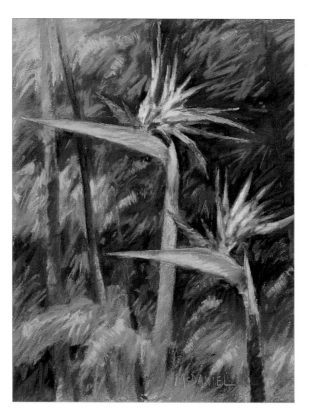

Paradise, pastel,
12 x 9" (30 x 23cm)
For a change of pace I took the class to a nursery to paint the flowers. Toward the end of the day I discovered these birds of paradise growing in a distant corner beyond a greenhouse. We assembled for an impromptu demonstration featuring the use of a dark background to make the orange blossoms appear vibrant.

Nor should the color sketch be excluded, for it is made from life, on-site. These are all part of the plein air experience.

Modified plein air painting

The painting that is started on location and completed in the studio also deserves discussion here, for the initial artistic connection was made at the site, and it still ignited the artist's direct response to the motif. There is always a danger in overworking the piece while in the comfort of the studio, but this needn't happen if you remain alert. Although there is a break in continuity when the gear is packed up and the painting brought home, some artists savor the objectivity gained by placing the painting in a new environment.

Another application of the outdoor painting experience is to gather several

Plein air events

Over the past several years, plein air events have become increasingly popular. Many local plein air groups have been formed, in which members paint outdoors together, share ideas, and form friendships. Periodically a special date and place are selected and advertised where many artists will gather at a specific site for a "paint-out," to which the public is often invited.

Gradually small paint-outs became larger, ultimately growing to become plein air events or festivals. Up to a week in duration, a plein air festival features artists who have been selected to come paint at a given location. A gallery, museum, or art organization serves as host for the duration and works with the community to coordinate, promote, and safeguard the event.

Artists, some from distant parts of the country, are invited to submit slides of their work for jurying months in

advance. Brochures and advertisements are sent out to the public and everyone prays for good weather. A few of the artists start trickling into town a day or two early, but most arrive on orientation day. Maps and information packets are handed out, old acquaintances are renewed, and each artist brings several blank canvases (or pastel papers) to be stamped by event officials. This is done to ensure that no previously done work is shown at the end of the week.

Each day the participants go out into the field, either alone or in small groups, and paint what they observe. Although the work days are long and exhausting, it is not uncommon for the artists to get together for dinner or a party — and sometimes an evening of painting "nocturnes." The creative energy is indeed contagious.

A gala exhibition and sale are held at the end of the week, and it is amazing

to see the quality and quantity of all these fresh paintings created in such a whirlwind. The desire to show good work alongside your colleagues places a mild amount of pressure on everyone, but the competition is generally friendly and the artists are quite supportive of one another.

One of the highlights of any plein air festival is the "Quick Draw Competition," in which the public is invited to watch participating artists work under a time limit of an hour or two. I am always astonished to see how good some painters are, and how they can paint so effectively under pressure. Yet it is heartening to see that not all the paintings turn out well. That is the risk, and that is part of the excitement. At a Quick Draw I feel like I'm giving a painting demo in front of a class, the only difference being that I don't have to talk as much.

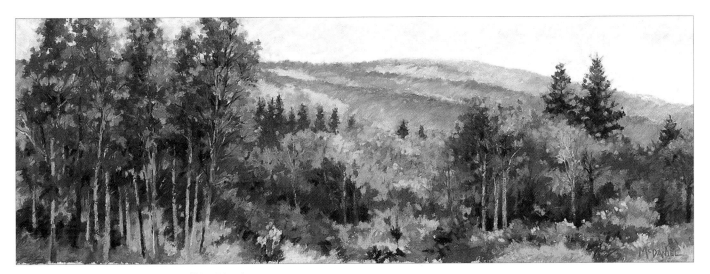

Jack London Ridge, pastel, 8 x 20" (20 x 51cm)

Midway through the week at Sonoma Plein Air, a number of us gathered at Jack London State Park to work. We painted in the morning, stopped for a marvelous group lunch, and then set out to paint again. Selecting a long narrow format, I blocked-in the scene with a dry wash and established the composition within an hour or so, restricting the forms to a middle value without much contrast. Stepping back frequently to judge the design, I gradually began expanding the range of values, adding highlights and dark accents to strengthen the impact of the painting.

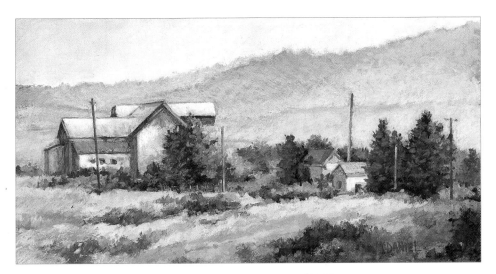

Point Reyes Station,
pastel, 8 x 15" (20 x 38cm)

One afternoon during a plein air event I began this painting. I only had it partially complete when the wind and fog changed the atmosphere considerably. Before I returned the following afternoon, I had the benefit of examining the unfinished painting away from the site, judging it in a neutral setting.

The International Paint-Out of September 11, 2004. Acadia National Park, Maine

The International Plein Air Painters (IPAP) sponsors an annual worldwide paint-out in mid-September. Artists from countries around the world simultaneously head out into the field and paint on location.

***Out to Pasture**, oil pastel, 11 x 14" (28 x 36cm)*
During a paint-out in Point Reyes, I spotted this abandoned horse trailer in a field at the outskirts of town. The sun was hot and there was no shade, but fortunately I brought a small picnic cooler for my oil pastels. The shadow from my French easel and the protection of the cooler kept the sticks firm enough to work well in spite of the heat.

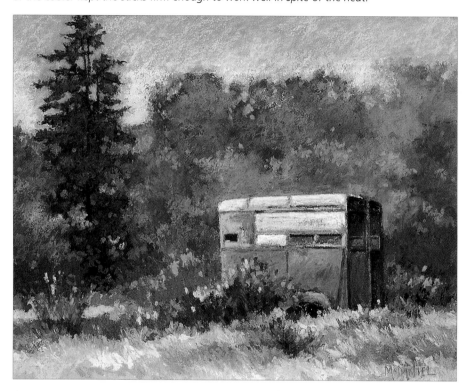

plein air pieces together, along with sketches or studies, and set them up in the studio. You can look at these references just as if you were looking out at the real scene, except they are already reduced to flat, two-dimensional surfaces, and have already been filtered through your own aesthetic paradigm. The underlying doctrine behind this method is that, regardless of the source, the artist's fundamental responsibility is to make a good painting, period.

Yet another variation that straddles a few boundaries is the act of painting through an open door or out the studio window. The scene to be viewed is every bit as much a plein air scene as any other, but the location of the artist is indoors, protected from the elements. It's a great way to work, even if it doesn't fit neatly into a descriptive category.

The "Plein Air Police." Guidelines are set at plein air events in order to ensure high standards and to educate the public as to the remarkable skill of the participating artists. Painters who understand the general logic, but still rebel against rules, speak of the Plein Air Police, who will supposedly monitor whether their painting was 95% completed on location, or merely 94%. However, the worthy souls at this table told me not to worry, and to just concentrate on painting.

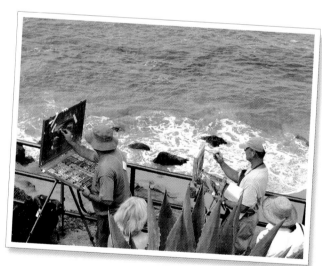

Quick-draw! Gil Dellinger and Jeff Horn are participating in a Quick Draw at the LPAPA paint-out.

September Reaction, pastel, 8 x 13" (20 x 33cm)

I was teaching a workshop in the New York's Hudson River Valley a few days following the September 11 attacks on the World Trade Center, about 100 miles away. At first I wasn't certain the class would be held, in light of the tragedy, but I soon discovered that everyone was eagerly looking forward to the workshop. We spent an intensely focused week of painting. We respected the gravity of the situation, yet we directed our attention toward color and composition in a concentrated way that some of us had never before experienced. The colors in my demo are unnatural, but then the mood of the week was unnatural. The main emphasis of the painting was emotional.

"I've been carting my easel out into the field for years, exploring the wonders of landscape painting. My experiences have been varied, from exhilarating to frustrating, but always intense."

In Preparation

Having the right equipment, and the right amount of equipment, and knowing how best to use it can make the difference between a painting dream and nightmare.

What a spectacular body of work we might have today if van Gogh had lived long enough to venture into the world of pastel. Plein air painting with pastel would have a much longer history, no doubt, for had van Gogh tried it he would have seen its versatility and suitability for outdoor painting.

"Pastel is a process which I should like to know. I shall certainly try it someday."

— Vincent van Gogh

Pastel is a wonderful medium: direct, vibrant, permanent, and remarkably forgiving. Unlike working with oil, when working with pastel you needn't spend time mixing colors or waiting for paint to dry. There is no glare from wet paint, nor any uneven sheen as a result of varying oil absorption rates. No solvents are required, and a finished painting is dry and therefore relatively easy to transport. Although it is wise to own a large collection of pastel colors, it is not necessary to take all of them out into the field for each outing. Often I take a very small assortment when I go out on sketching trips.

Depending upon stylistic approach and personal preference, one artist may work effectively with a minimal selection of colors while another may prefer a substantial assortment of pastels. In the first case, the concept is usually more abstract, with colors simplified and an emphasis placed on form or value relationships. Those who paint with a full chromatic range might not require 200 colors each time they go into the field, but it's hard to know in advance which colors will be needed. So they take a complete range in order to choose the particular colors needed for the painting.

Let's now look at the different types of pastels available, the surfaces and all the other odds and ends you may need.

Baby Beach, pastel, 10 x 16" (25 x 41cm)

Pastel Materials

Pastel is pure pigment mixed with a dry binder (gum tragacanth) then rolled or pressed into sticks. The pigment is the same as that used for oil paints or watercolors, only the binder is different. When applied to a surface with a receptive texture, such as rough paper, sanded paper, or abrasive board, the colored pigment becomes embedded in the tiny crevices, the "tooth" of the paper.

Pastels are divided into two main categories, soft pastels and oil pastels. Oil pastels differ in that they contain (surprise!) oil. Soft pastels have a much longer history and enjoy much wider use. Soft pastels (are you ready for this?) are divided into soft and hard. So, when you mention a hard pastel you are also referring to a type of soft pastel.

Soft Pastels

Soft pastels are available in a number of superior brands, each with slightly different characteristics. Try several types to discover which are best suited for you. I use a mixture of brands when I work, as do many pastel artists. You'll find that most artist-grade pastels are richly pigmented.

It's wise to start out with a basic set of 60 colors or so and start building up your supply with individual sticks of different brands until you develop your preferences. You can beef up a basic set by adding deep, dark shades, and some interesting pale tints. If your local art supply store doesn't allow you to buy individual sticks, or if their selection is insufficient, you can request color charts from a mail order art supply company. Then it is reasonably

easy to purchase single sticks from open stock.

Medium Pastels

In reality these are soft pastels, but they're more firm than the very softest pastels. Although they cannot achieve all the effects of the softest, nor of the hardest, they have some of the qualities of each, and work well for the majority of techniques. Many pastelists use just one set of medium pastels rather than a set of soft and a set of hard.

Hard Pastels

Obviously the firmest of all, hard pastels are what I use in the initial stages of a painting, while blocking-in an image. Since they are dense in their makeup, less pigment is distributed on the paper with each stroke than with a

The Richard McDaniel Plein Air Assortment, a 78-color pastel set by Great American Artworks was designed to fit inside the drawer of a standard French easel. Be sure to replace the lid before folding up the easel.

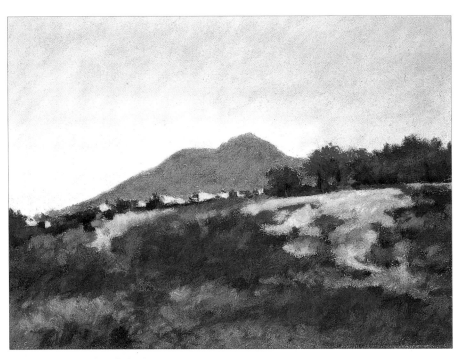

Mount Tam from San Rafael,
pastel, 4 x 6" (10 x 16cm)
Many are familiar with the presence of Mount Tamalpais as it overlooks the northern edge of San Francisco Bay. As I drove south along Highway 101 near San Rafael one day, I simply pulled off onto a frontage road and completed this painting in my car, using the steering wheel as a makeshift easel.

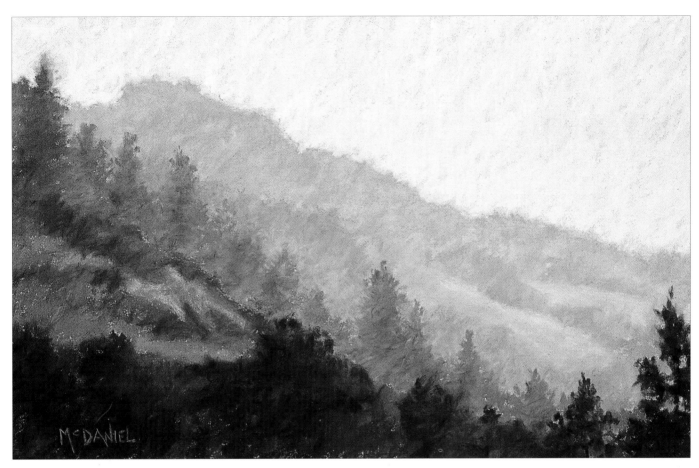

Eagle Rock, Lifting Fog, 7 x 11" (18 x 28cm)
I feel fortunate that this is the view out the bedroom window, and grateful for the balcony that makes it possible to paint Eagle Rock en plein air. Most mornings are bright and clear but some days are so foggy or stormy that the rock disappears completely. As the sun burns off the fog and Eagle Rock reappears, the colors begin to brighten and the forms gradually emerge.

softer pastel. As a result, the paper's tooth does not become clogged with pigment so quickly. This allows me to build up a few layers, then follow with soft pastels on top. Hard pastels are also capable of creating a number of subtle effects when employed in the final stages of a painting.

It helps to obtain as many colors as possible in order to have a selection of interesting choices while painting. Hard pastels can be sharpened to various wedge shapes or points, creating a useful tool for a number of effects.

Pastel Pencils

Pastel pencils offer essentially the same quality of color as hard pastels, but are shaped into a thin rod like a traditional wood-cased pencil. Since they can be sharpened to a fine point, they are handy for clarifying edges and for rendering

details such as grasses and branches.

Pastel pencils are also useful for blending color in a pastel painting. Instead of softening a tone by smudging, many artists prefer to tie the colors together by superimposing a new layer of hatched strokes with a pastel pencil. This procedure blends the underlying colors together without muddying them, and adds rhythmical variations for the top strokes as well.

Oil Pastels

Unlike soft pastels, oil pastels adhere to almost any surface—they don't need a paper with tooth. Oil pastels are a combination of pure pigment, oil, and wax that have been molded into a crayon or pastel shape. They aren't as bright as soft pastels since the oil binder decreases the intensity of the pigment, but their color is far from dull. They are available in a full range of

opaque, permanent colors, especially deep, rich darks, and can be worked up in layers, scratched into (sgraffito), or scraped back down and built up again. They possess a notable capacity for slurring colors together to achieve painterly effects.

Anyone who had a special love affair with crayons as a child should investigate oil pastels. They create no dust and are extremely portable. I often use the center scraps of mats cut from museum board as a surface when I work with oil pastels. These are archival, lightweight and firm, and since they are scraps, they are essentially free.

Since the pigments in oil pastels have already been darkened with the admixture of oil and wax, a final varnish or fixative does not have much of a darkening effect. For this reason, many artists who use oil pastels will apply a coat of varnish over the completed

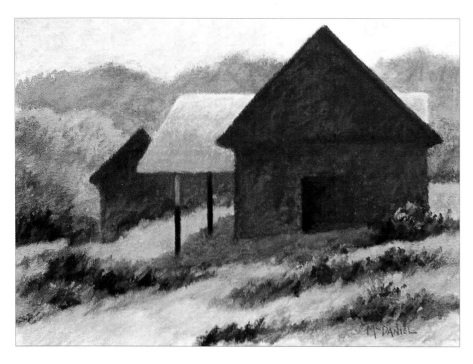

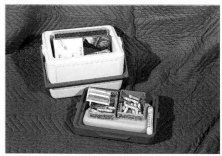

Blue Barn, oil pastel on museum board, 9 x 12" (23 x 30cm)
I chose this familiar scene in Woodstock when I first began to experiment with oil pastels.

The sun can make oil pastels quite soft. On hot days, they become too soft for me to use effectively so I transport the oil pastels in a little cooler with a freezer pack. By keeping the pastels cool (and in the shade) I've found that they stay firm.

image and exhibit the painting without glass. This may be acceptable in the short term, but traditional framing under glass is more stable.

Oil pastels and soft pastels are not customarily mixed, except for experimental techniques. I find it best to have a set of each and to use them separately.

One caution: don't leave oil pastels out in the sun, or enclosed in a car on a hot day. If you must be out in the heat, try bringing a small insulated picnic cooler with a frozen gel-pack. Place the oil pastels on top of the gel-pack and they'll stay as firm and cool as you need.

A Pastel Set for Working on Location

It is not absolutely necessary to have a complete "set" when going out into the field. Certainly when hiking a fair distance, you will want to minimize the weight of your materials. But not everyone wants to backpack into the wilderness with a skeleton set of colors—at least not all the time. Indeed, plein air painting can encompass a broad range of styles and sensibilities, from the minimal-material hiker to the artist driving a van equipped as a "studio on wheels."

When I want to work with a sensibly complete range of useful colors I carry a collection of hard pastels, several

pastel pencils, and a colorful assortment of soft pastels called the Richard McDaniel Plein Air Assortment. The 78-color set is manufactured by Great American Artworks, and personally selected by me to provide a full range of colors, from pale tints to deep shades. The creamy-soft texture of the pastels is wonderfully consistent throughout the entire set and the intensely pigmented colors are well suited for any landscape motif you might encounter.

Pastel Papers and Supports

You owe it to yourself to use good-quality, acid-free paper for your pastel paintings. Since oil pastels will adhere to most any surface, I will concentrate here on supports for soft pastel, which need a surface texture, or tooth, to hold the particles of pigment. Any sturdy paper will work, as long as it has some sort of texture, and pastelists with different styles may have dissimilar requirements for their papers. A tinted paper, for example, is favored by many, since its color can be incorporated into the design of the artwork. Tinted papers are also valued by plein air painters because they reflect less glare than white paper.

In order to work on a stable surface, I simply tape my paper to a foam board as backing. Foam board makes a

marvelous support, it is firm but lightweight, and is available acid-free or in solid black to eliminate glare. Unframed paintings are easier to store vertically when attached to such a board, and the foam board works well as a backer board when the artwork is framed.

You may also experiment with a number of marble dust or pumice recipes that can be brushed or rolled onto watercolor paper, printmaking paper, or matboard. Yet another alternative is to use a prepared board. This surface has the advantage of being washable. If your image is a disaster, you can put the entire board under the faucet and scrub it out with a stiff brush. You can also carefully scrub out a small portion of the design without disturbing the rest of the image.

Fixatives and Accessories

I don't use fixatives so I won't go into detail here. Although they isolate one layer from another, and even provide some extra tooth for subsequent layers, in my opinion, fixatives tend to darken the pigments. As a result, pastelists who do use fixatives generally use them early on in the work, and leave the final layers of pigment untouched. Once framed under glass, a pastel painting is well protected without the use of a fixative.

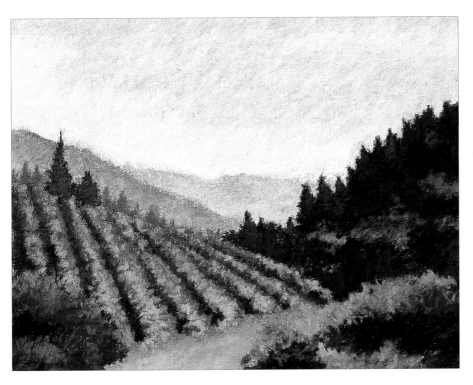

Hillside Vineyard, oil pastel on museum
board 9 x 12" (23 x 30cm)
*Oil pastels grab onto the paper and easily
permit layering techniques, as evident in
this sky. The subtle blending of color in the
road, as well as the highlights on the
foliage, is a result of oil pastel's ability to
stick onto layers of previously applied color.*

Plein Air Equipment and its use

In order to make the most of your
outdoor painting efforts, you need
to eliminate as many mechanical
impediments as possible. If your
materials and equipment are
appropriate to the task, and you are
comfortable with their use, then all
your energy can be directed toward
the main event: painting.

This simple statement resonates
well with any artist who has ever been
trying to paint, only to be constantly
distracted by a wobbly easel, or the
lack of some much-needed supplies.
It's hard enough to navigate the
challenges of image-making without the
added burden of equipment hassles.

Canned Air

One of the most useful pastel
accessories I've discovered is a can of
compressed air, available at most
camera stores. It sends a precise blast
of air through a thin nozzle to any area
of your painting that needs correction.
The force of the air easily removes
unwanted strokes of pastel, restoring
the original surface tooth of the paper.
Canned air is also helpful for safely
blasting away pastel smudges that have
soiled a mat. Although it may be a little
bulky for some outdoor work, canned
air is a great item to keep in the studio
— as long as you remember to step

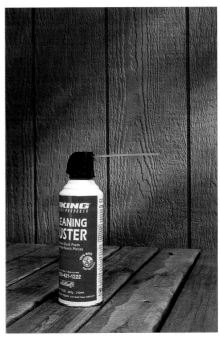

*Canned air is now fluorocarbon-free and
ozone-safe.*

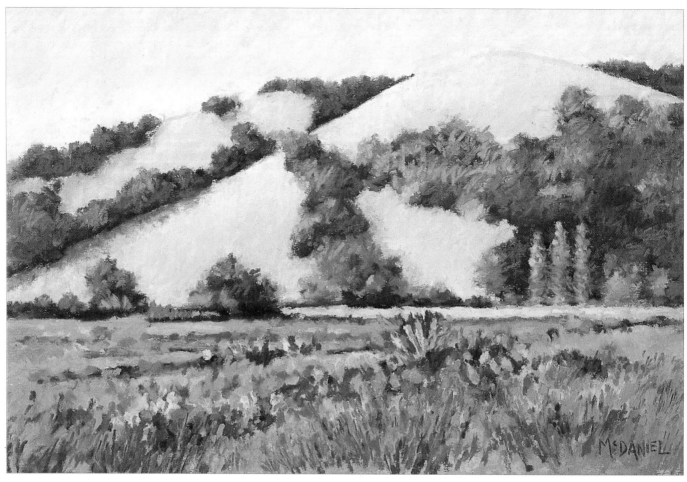

Lavender Splash, 8 x 12" (20 x 30cm)

The extraordinary covering power of pastel allowed me to paint a realistic foreground, step back to evaluate, then go back in with a more emotional, calligraphic, and abstracted approach. New strokes of pastel can be applied directly over original layers without muddying the image.

outside the studio before you use it.

Easels

An easel is usually considered your most important piece of equipment. Perhaps I should say "work support" rather than easel, for there are a few other alternatives. The work support must be stable and adjustable, and it must be reasonably portable for outdoor work. Veteran painters are always trying to find the optimum combination of portability, stability, and adjustability.

My easel of choice whenever I don't need to do much hiking (or flying) is the French easel. It was designed specifically for outdoor work, it's sturdy, and its legs are fully adjustable for sitting or standing. The legs even tuck away so that the easel can be used

on a picnic table.

There are two sizes of French easel: full box and half box. Both are like a combination easel and paintbox. The legs and painting support are essentially the same with either style, it is only the size of the paintbox that differs. A drawing board or canvas can be held at any position from horizontal to vertical, and the legs are especially adaptable to uneven terrain. A particularly handy feature is its drawer, which pulls out to the front of the paint tray and can be used as a convenient shelf.

I've been using my French easel for more than 20 years without much trouble. Repairs and maintenance are easy to perform since it is made of wood, with brass hardware. Remember to periodically check that all the screws and bolts are securely fastened. Other

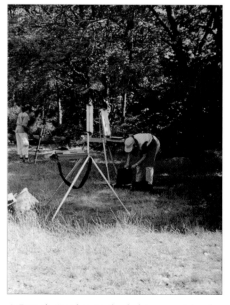

A French easel, a pochade box on a tripod, and an aluminum alloy easel in use in Provence.

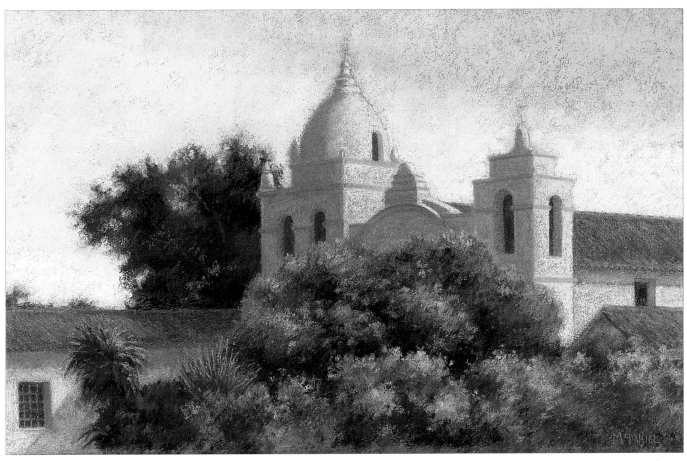

Carmel Mission, pastel on hand-made pumice board, 15 x 24" (38 x 61cm)
For this image I used a hand-made painting surface composed of pumice and acrylic gel, which I applied to a hard board panel with a low nap paint roller. The pumice texture helped describe the stucco finish of the old mission. If you make pumice boards that are too rough you can sand them down a little bit.

The all-in-one pastel carrier and pochade box mounted on a tripod is convenient. The dust tray beneath the painting panel is cleverly held in place with magnets. It is therefore extremely easy to remove the tray and shake off pastel dust.

than mishaps from clumsy baggage handlers, loose hardware is the primary cause of damage to French easels. Rubbing a bar of soap along the wooden moving parts of the easel keeps them sliding easily.

Another popular easel among plein air painters is made of aluminum alloy and polymers, it is lightweight and strong, and very adjustable. Like the French easel, this type includes a paintbox compartment that can hold a considerable amount of supplies, and can be outfitted specifically for pastels.

The weight of these easels when empty is not bad (9 lbs. for the aluminum, 11.5 lbs. for the half-box French easel). It is the weight of all the material you put inside the box that makes it heavy. Many artists carry these easels nearly empty, and distribute the weight of their supplies into a backpack.

Pochade Boxes

For years, artists have been devising clever gadgets to make outdoor painting more convenient. The easels mentioned above are extremely useful for most plein air painting, but there are times when a further reduction in size is in order. A pochade box is a miniature paintbox used for creating small works on location, especially when that location requires some effort to reach. For years I used an old school lunchbox for this purpose, but the new boxes are much better, though they aren't nearly as stylish.

Most pochade boxes have a tripod mount so they can be attached to a standard camera tripod. Since lightweight tripods fold up to a compact size, the combination of a tripod and pochade box is extremely portable. For pastel painting you will need to carry a small selection of

Seaway, preliminary pencil sketch,
8 x 11" (20 x 28cm)

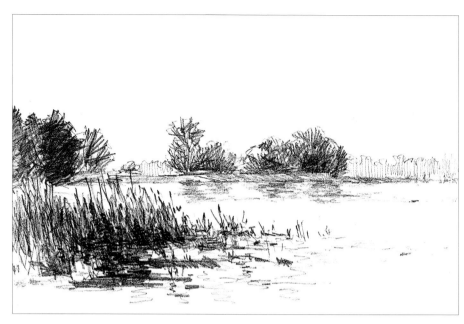

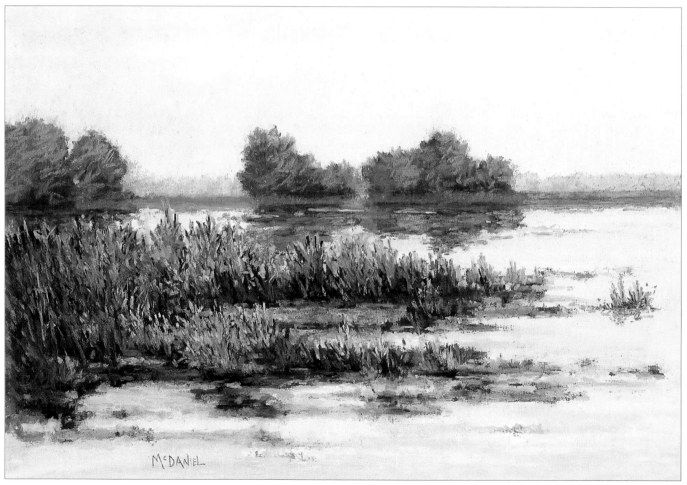

Seaway, pastel on sanded paper, 8 x 11" (20 x 28cm)
*Hard and soft pastels have their own characteristic traits. In Seaway I have used them each
repeatedly, back and forth. I used soft pastels for the final layers of the sky and water while
the reeds incorporate many strokes of hard pastel as well as a few accent touches of soft.*

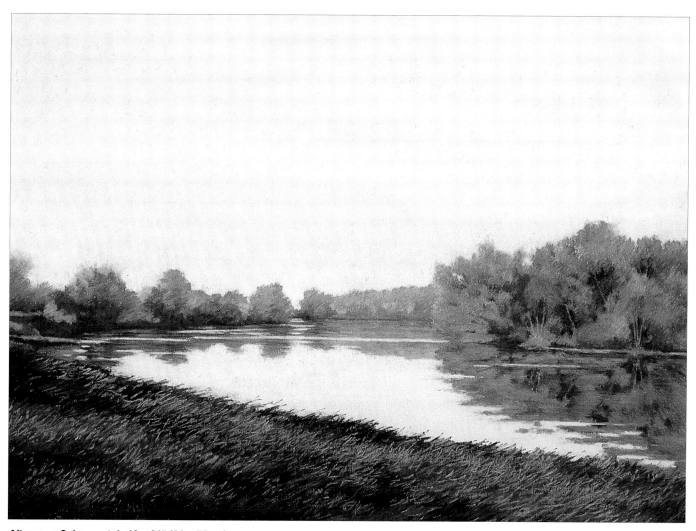

***Afternoon Calm**, pastel, 13 x 21" (33 x 53cm)*
In contrast to Carmel Mission on page 35, I used a fine-grit sandpaper for this painting. The water is placid and glassy. My intent was to convey the calmness of the scene. Therefore, a paper with a very smooth texture was most appropriate.

pastels in the pochade box, or carry a larger assortment in a separate container. Some artists travel with two tripods: one to hold their painting, and one to hold a tray of pastels at a convenient height.

A very nice thing about any painting system on a tripod is that it can be rotated without moving the tripod legs. You can spin the art piece to keep it free from the sunlight or to examine the painting from different angles.

Pastel Boxes

There are many containers suitable for safely transporting your pastels. The manufacturer's original packing will work well if you only use that one set of pastels, or if you choose to lug

around a few containers. Most pastelists acquire a variety of brands and ultimately search for some sort of universal carrier. The first thing you might consider is the quantity of colors you deem necessary and the distance you plan to tote your supplies. I have more than one pastel container, each equipped differently. For sketching trips I keep a minimal selection of colors in a very compact box. This little container fits right inside a pochade box, and I use it often for my small paintings. See the little gems on page 15.

Several foam-lined pastel boxes are currently available. These boxes usually don't have individual slots for each pastel. Instead, they have divided sections into which you can organize

a few sticks of similar color, even if they are different sizes and different brands. Once the cover is attached for transport, the foam holds all the pastels in place. Breakage is thereby kept to a minimum.

Some pastel carriers combine many useful features together in one container. For example, a foam-lined wooden box may safely hold a large selection of colors, and have an attachment so that it can be mounted on a tripod. It also may have a simple panel-holder attachment so that it functions like a pochade box. If you wish to use your French easel for greater stability, most pastel carriers fit conveniently on the open drawer of the easel.

I have seen countless arrangements

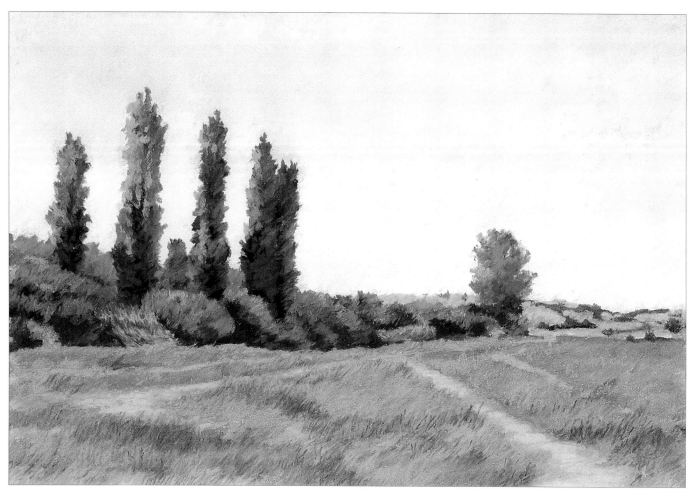

***Converging Paths**, pastel, 10 x 16" (25 x 41cm)*
There was no shade out in the field where I was working so I set up an umbrella.

A pair of chairs may not be the most convenient to carry a long distance, but the system works fine in the back yard if you don't have a portable easel available.

A painter's umbrella should be a neutral color so that it doesn't create a distracting glow on the painting. This one is gray, which is easier on the eyes than pure white when you stand back to look at the painting from a distance.

of tables or trays to hold pastels. French easels or aluminum alloy easels are well equipped to hold a number of pastels in easy view, and some pastel carriers or pochade outfits provide enough space for a modest pastel assortment. But if you need more space, consider an old fashioned tin TV tray on its lightweight folding legs. These tables are too short to use while standing at your easel, but if you slide pieces of PVC tubing over the ends of each leg you can increase the height without noticeably increasing the weight.

Chairs

A simple and oft-overlooked alternative to an easel is the use of two folding chairs. Set up the chairs facing each other, sit in one chair with the seat of the other just opposite your knees. You can rest a drawing board against the back of the chair (with pastel paper taped to the

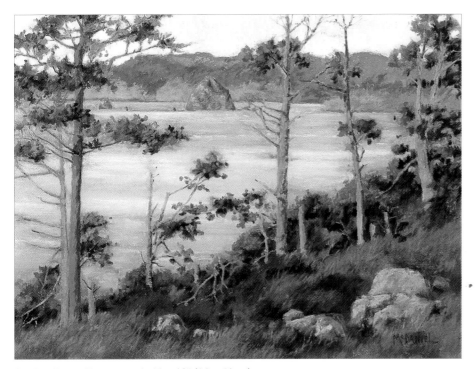

Pacific Happy Hour, pastel, 12 x 16" (30 x 41cm)

The purpose of any viewfinder is to block out peripheral detail so that you can concentrate on the format of the composition.

board at the appropriate height) while you keep your pastel supplies within easy reach on the seat of the chair. Remember to stand up and walk away from the painting occasionally. This may require moving your "sitting chair" out of the way so that you have a clear view to the work on your "easel chair."

Some artists take a variety of portable tables, chairs, and accessories out into the field in order to paint in comfort with a large assortment of pastels. Weight is obviously a factor, especially the longer you walk. If you really need a lot, and if the ground is level, consider putting everything in a cart. If you have an old golf cart that you can modify, its large wheels can negotiate fairly rough terrain. Otherwise, just bring less gear.

Although you can work in a sketchbook or on a pastel pad while sitting on a rock, you may find it a bother to get up and place your painting where you can see it as you step back to examine the composition. Fortunately, one of the benefits of using pastels on location is the lack of reflective glare that you might get from wet paint. The completely matte surface of pastel allows you to view the work

from practically any angle and still get an accurate reading of the image.

Painting Umbrella

It is important to keep your painting out of the sun's glare because it's hard on the eyes, and it's also difficult to judge values properly. But shade isn't always on hand. The answer is to create your own shade with a tarp (provided you have something to which it can be tied) or an artist's umbrella. An inexpensive clamp-on umbrella will work, although the quality of the clamping hardware is likely to be suspect. By all means, avoid brightly colored umbrellas, as they will transmit colored light onto your painting. White, black, or gray are the best. A colored umbrella can be painted with fabric paint, dark on the underside to eliminate reflection, and light on the top to dispel heat.

Be especially careful of the wind if you use an umbrella, and don't leave your easel unattended without collapsing the umbrella. Plenty of painters will recommend that you never attach an umbrella directly to your easel but instead to a separate tripod.

Viewing Aids

One of the chief differences between landscape and portrait, or still life, is that landscape boundaries are not defined. The scene goes on and on and on. The task of selecting a motif and composing a painting can be daunting at times. A viewfinder is always a great help. This can be an empty slide mount (extremely portable), a Viewcatcher (small adjustable plastic viewfinder), or two L-shaped pieces of mat board that you can hold up against the scene, and look through to examine the potential composition.

I like to carry a small pocket mirror. The one I have is about two by three inches and is housed in a protective plastic case. As I step away and turn my back to my painting, I look into the mirror and view the painting in reverse. It helps to point out design flaws that might otherwise be overlooked.

A pair of binoculars is often carried by nature-lovers when they head out on a hike. Artists might enjoy the binocs for the same purpose, but they will frequently hold them turned around backwards, using them as a makeshift reducing glass. Looking at your painting through reversed

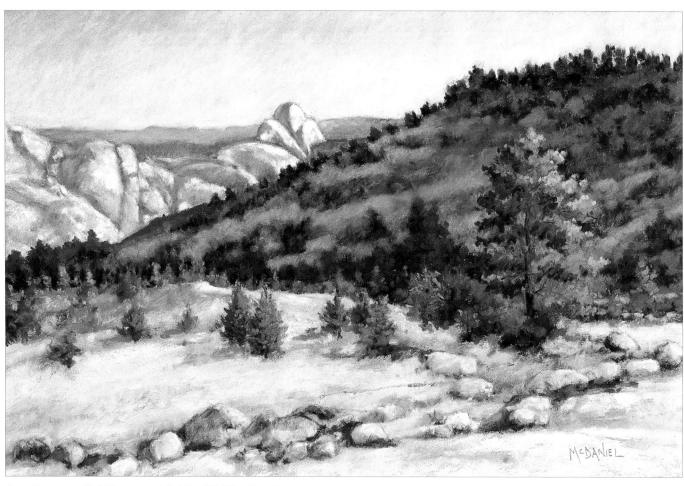

Sneaking up on Half Dome, pastel, 10 x 15" (25 x 38cm)
This is not the familiar view of the celebrated rock, and I was surprised when I saw it from this position. However, I liked the unusual viewpoint, and the opportunity of painting a "landmark" that wasn't immediately identifiable.

binoculars will reduce the image to the size of a postage stamp without your having to step back from the easel. As with using a mirror, it becomes easy to spot errors in the composition.

"Studios on Wheels"
While many urbanites depend upon public transportation, most everyone else owns a car these days. If you mix a plein air painter with a car, you will most likely get some form of "studio on wheels." Then you can take all your favorite supplies, plus your easy chair, CD player, picnic basket, and latte machine.

Unless you are hiking deep into the backcountry to paint, most locations can

be reached by car. If you can't drive right up to the site, you can usually get close enough so that it's only a short walk. Even serious treks into the wilderness can be aptly supported by a "base camp" studio-on-wheels.

Clothing and Accessories
Dress in layers of loose and comfy clothing. There is no need to wear the dark colors so often worn by oil painters (light colors will reflect onto a wet canvas, causing unwanted glare), but avoid brightly colored garb. The color of your bright red shirt will bounce onto the paper, providing a nice rosy glow while you are up close, working away on the image. As soon as

you walk away the glow will disappear.

A viewfinder, sketchbook, pens, pencils and erasers won't add much weight but are indispensable. If you are not traveling on an airplane, keep a penknife or single-edged razor blade in your supply box to sharpen pastel pencils and hard pastels, and to slice an apple.

Your hands can get mighty dirty when you're using pastels. A cloth or paper towel will help for much of the time, but a moist towelette is even better. For plein air painting you may want to look for individually foil-packaged wet wipes. Keep a few in your pocket. Lightweight odds and ends such as tape, string, bungee cords, plastic bags, and baby wipes can come in handy too. Trash bags are lightweight and work as instant rain gear.

Always include basic protective sundries when you head out into the field: lip balm, sunscreen, insect repellant, cookies, and of course water. And don't forget your hat. A hat with a brim is necessary — to keep your head cool in summer and warm in winter, shade your eyes from the sun's glare, and to discourage the occasional flying insect from getting too close to your face.

Consider packing a few pieces of hard candy or cough drops in your pocket. It is amazing how uncomfortable a dry and scratchy throat can make you feel, and how grateful you might be for a piece of candy. There have been times when a little cough drop has forestalled my heading home early from an otherwise productive outing.

Most likely you'll need something to carry all this gear. A paper bag will certainly work, but a daypack is much more effective. I've found that small backpacks function quite well, as they usually have assorted pockets and, more importantly, they can be strapped to your back or slung over the shoulder, leaving your hands free. Whatever you choose, try to reserve the container exclusively for painting outdoors. It can be quite a hassle if you

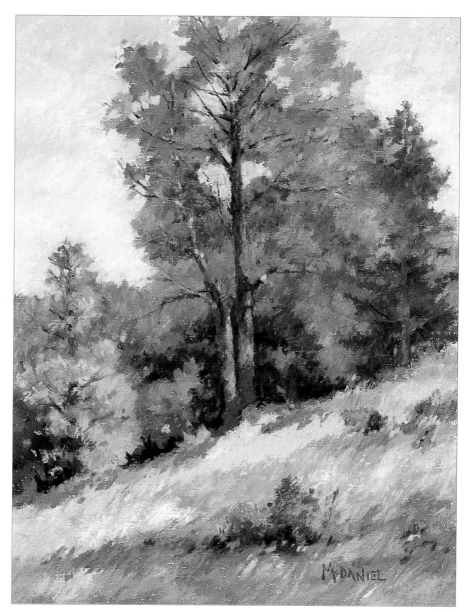

Cottonwood at Fredericksburg, 12 x 9" (30 x 23cm)
What would otherwise be a boring composition with its centrally placed tree is kept from being static by subordinate elements. The slope provides movement toward the pale tree on the left, which is joined to the mass of the foreground because of its similar value. Conversely, the dark tree at right stays separate from the foreground. The lower horizon on the left results in more open sky on the left side of the painting.

need to empty out the camping supplies and pack up the art supplies for each session.

The Boy Scouts' motto of "be prepared" has significant meaning for the plein air painter. Having the right equipment, and the right amount of equipment, and knowing how best to use it can make the difference between a painting dream and nightmare.

Pastel Application Methods

In order to utilize your pastels fully, you must become familiar with the many methods for applying the pigment, and the multitude of marks that pastels can make. Before working to create an image, practice the strokes described here, and experiment with a few different papers.

There are many ways to apply pastel, and each has its own look. Combining these methods in your own manner will give a specific bearing to your work: your own handwriting. The surface upon which the pastel is applied can also create a distinct impression. Whether that surface is smooth, rough, or toned will have a profound influence on the appearance of each pastel stroke.

Before getting into the application methods, I'd like to mention touch. Variety in pressure is one of the most important skills for a pastelist to master. Use a light touch while stroking a stick back and forth over the paper and the mark will be subtle. The more pressure, the more intense the mark. This is like dynamics in music. You can strike a piano key with vigor or caress it gently and the resultant sound will be loud or soft — even though the pitch of the note is identical.

Also learn to vary the pressure you use while working. A line drawn with uniform pressure does not convey the rhythm and expressive qualities that are found in a line created with varying pressure. Such a line is vibrant and alive. It knows how to dance.

Linear Strokes

The character of a line will vary depending upon the amount of pressure employed, and whether you use hard pastel, soft pastel, or pastel pencil. By using the tip of a razor-sharpened hard pastel or a pastel pencil, you can create thin lines, and somewhat thicker lines with soft pastels. I like to use the long edge of hard pastels for sharp linear strokes. Although pastel pencils make fine lines and are clean to use, don't get in the habit of using them too much in an underpainting. Their use encourages an overemphasis on details at too early a stage. Rather, use them later for clarifying edges, feathering, and drawing final details.

Scribble Strokes

Linear to a degree, but very relaxed and kinetic, a scribble stroke is made with the tip of the pastel stick. You scribble in any direction your hand chooses to go. With practice, you may develop a personal scribble that is aesthetically pleasing and uniquely your own mark.

Hatching and Crosshatching

An impression of solid tone can be achieved with a series of closely grouped parallel strokes, known as hatch marks. These may be controlled, uniformly spaced lines, or more relaxed, like a compressed scribble. The tone is deepened by the closeness of the lines, or by applying additional layers of hatching at slightly differing angles. This is called a crosshatch, and is one of the most useful of all methods for developing values in the visual arts.

Hard pastels and pastel pencils are most appropriate for crosshatching because their lines remain distinct. Soft pastels will work — they just make a thicker and softer line, with the strokes tending to merge into a single tone. Soft pastel hatching is much more effective for large-scale work. Crosshatching, used alone or with other techniques, is a useful system for manipulating an image, slowly weaving colors together to build up a form, or modifying the form after it has been rendered.

A combination of hard and soft pastels is often a good choice since you may not want the hatching to look too mechanical. I like hatch marks to come and go, to barely show up at times, perhaps as certain surfaces turn toward the light. Nor do all strokes need to be absolutely parallel. An "organic" kind of hatching, with lines radiating every which way, is popular with landscape painters, as the lines mimic the different planes found in nature.

Side Strokes

Using a side stroke is a much faster way to build up tone. Hold the stick on its side and drag it across the paper. Half sticks work best. You can control the density of the mark by using more or less pressure.

Wildwood, 6 x 9" (16 x 23cm)

Color and organic scribble strokes are used here to emphasize the life force, or the power of growth, in this cluster of tangled branches. This is an emotional rendering of the trees, not a photographic portrait. The intensity of pastel pigments, combined with the ease of their direct application, allows a great range of stylistic responses to nature.

Summer Haze, pastel, 8 x 12" (20 x 30cm)
A sensible amount of slurring and blending contributed to the soft atmosphere in this painting. Most of the colors are warm and hazy, with a few accents of intense color for punch.

Blending

If done judiciously, blending is a good way to model form, soften edges, and create subtle gradations of color. Blending is also useful for describing the hazy soft light of the sky. Make sure there is plenty of pigment on the paper, then gently rub one color into another. You can use a soft cloth, a blending stump, or if they're dry and free of grease, fingers make superb blending tools. Lay down some colors next to each other and blend them with your fingers. Keep blending. Overblend them until they are smooth but lifeless. Now you know one of the limits. Recognize overblending and avoid it in the future.

Slurring

Slurring is a type of casual, or incomplete blending. You can push a few colors around by dragging a pastel stick through a shape, pulling some of the pigment along, while at the same time depositing fresh color from the stick

in your hand. This method looks more animated than a thoroughly blended passage. Hard pastels work extremely well for slurring because they are firm enough to push around the existing pastel, yet they are strongly pigmented, and will add plenty of their own color.

Feathering

With feathering, the idea is to drag a thin layer of hatched lines over the top of a previously painted section, allowing some of the underlayer to show through. By feathering over two adjacent shapes, you can unify them with the top layer, increasing color harmony. The effect is reminiscent of a glaze in oil painting or a wash in watercolor, and is the best way to suggest transparency in pastels.

Pastel pencils or hard pastels feather better than soft pastels unless you use an exceedingly light touch. Areas of a painting can either be intensified (by

The versatility of pastels is seen in these marks (top to bottom): orange hard pastel with decreasing pressure; blue hard pastel with uniform pressure; blue hard pastel with varying pressure; yellow soft pastel with decreasing pressure; and yellow soft pastel with uniform pressure.

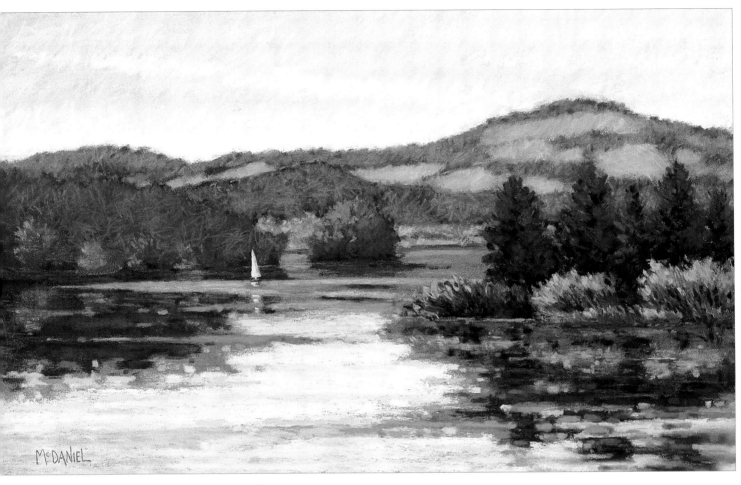

Spring Sail on Spring Lake, pastel, 10 x 16
What luck! I began this piece as a demo painting in a workshop. As I was establishing the composition and applying my first notes of color, a solitary sailboat entered my view at the left. Aha! All I had to do was keep working until the little white triangle sailed over to the right spot in the painting.

feathering with bright colors) or toned down (using duller or darker colors for the feathering layer). Also try glazing over a passage with a pastel pencil to modify the warmth of a form, or introduce the complementary hue to neutralize the color.

Scumbling

This is simply a beefed-up version of feathering. Drag one color over another, allowing a small amount of the underlayer to show through. A side stroke with soft pastel works well, especially if the paper has a pronounced tooth. The scumbled layer will catch the elevated ridges of the paper while the bottom layer of color will remain visible where it clings to the lower valleys.

Pouncing

The subtlest of procedures, pouncing is a technique I use for altering the intensity of a form without destroying its detail. I pounce when a mark is correctly painted, but appears, for example, just a bit too dark. I tap my finger elsewhere on the surface of the painting where there is lighter pigment, in such a way that I pick up a thin layer of light-colored pastel on my fingertip. Without wiping my finger I tap it on top of the dark passage, thereby depositing some of the light pastel on top of the dark, but leaving the shape essentially unchanged. I repeat this as often as needed to lighten the area sufficiently.

A variation on this approach is to tap on the light area, then on the dark, then on the light again, and so on. Each pounce will pick up some color and deposit some color, so that repeated pouncing gradually draws the two colors closer to one another. It is a way to quickly reduce contrast, making the dark lighter while making the light darker. Pouncing back and forth between a yellow passage and a red passage moves each color toward orange.

Free Form

Use every kind of slash and squiggle that you can imagine: short strokes, long strokes, twisting and turning strokes. This idea is to reveal your individual artist's handwriting in your work.

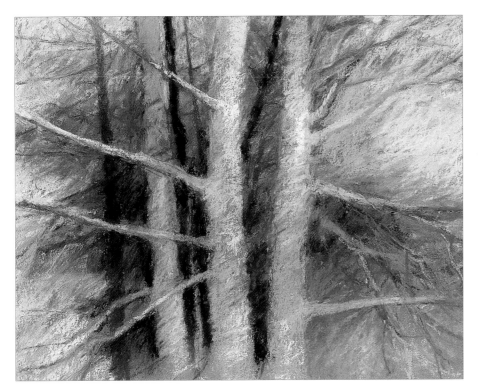

Tree-o, pastel, 8 x 10" (20 x 25cm)
A cropped image provides a whole world of compositional possibilities. Instead of the whole trees, or the treetops, I focused on the middle of the trees. The loose scribble strokes have enough substance to describe volume while maintaining a casual sketchiness.

Virtually any abrasive surface can be put to use for shaping a hard pastel.

Sometimes I like to apply a dry-wash layer when I begin a sky. To accomplish this I find it easiest to tilt the easel back to a near-horizontal position. Any excess pastel stays in place as I rub the pigment into the paper.

I like to work at different angles when I'm painting with pastels. Unlike oil, there is no reflective glare from wet paint so it's possible to tip the easel to any orientation that is comfortable for painting a particular passage. I even walk around and paint from the side when the panel is tipped back to a near-horizontal position.

Wet Wash

A wet wash, as detailed in Demonstrations 4 and 5 in this book, distributes the color, working it into the paper, much the way an oil painter stains the canvas as an underpainting. A wash breaks up the individual pastel strokes and blends the area into a solid background color. You can then apply a "topcoat" of fresh pastel, with the wash creating the background color in place of the original color of the paper. Turpentine and water are the liquids most commonly used.

Dry Wash

Similar to a wet wash in its result, a dry wash is created by rubbing the first layer of pastel into the paper, as shown in Demonstration 3. The technique is like over-blending, so the colors become somewhat muted. (Sanded papers are unsuitable for dry wash because their surface is so assertive.)

Basic Layering

Describing a process in many steps can make it seem like a cumbersome procedure, not at all quick, and not direct enough for plein air painting. However, layering is one of the best methods for developing a lively surface in pastel paintings. The technique is simple, forgiving, and easy to learn, which is why it's the subject of Demonstration 1.

For me, layering is a natural extension of the way I draw. I've become accustomed to building up

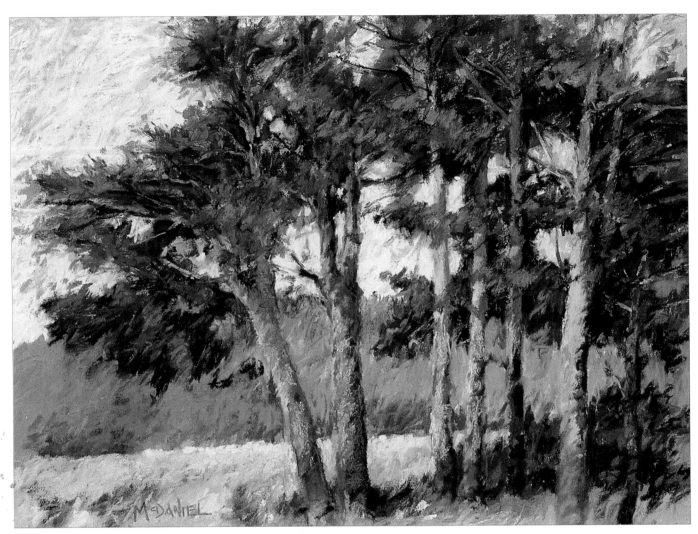

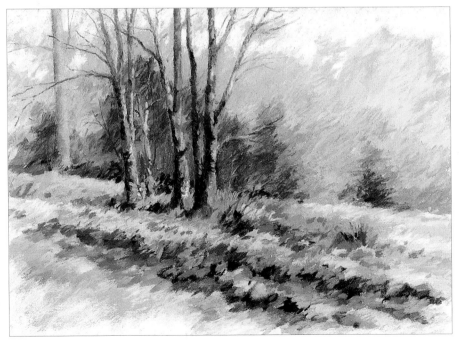

Lunchtime in Mendocino,
pastel, 9 x 12" (23 x 30cm)
Weaving colors together in layers not only
provides rhythm and energy, it is a great
way to create colors you might not
otherwise have. By layering and slurring
pastels you can optically mix the pigment
to suggest a wide array of colors.

Treeforms, pastel, 9 x 12" (23 x 30cm)
Corrections and adjustments are easy to
make with pastel. It is a very forgiving
medium. The straight tree trunk to the left
was originally a pinkish color that grouped
with the central cluster of trees. However,
the color was too hot and the form did not
stay back. I toned it down with cooler colors
without having to remove the pink.

my darks by crosshatching, and it goes fairly quickly while providing ample leeway for exploring or developing the composition gradually.

Unlike fluid media, such as watercolor or oil, pastel colors are not mixed together on a palette then applied to the paper. But a pastelist is not restricted to having separate sticks of pastel for each color needed in the painting. You can achieve a tremendous amount of color variety by layering. At times the process proves as effective as mixing wet paint.

I begin with a loosely applied layer that only partially covers a form. The next layer is sparsely hatched on top of the first, concealing some strokes from the first layer while leaving others visible. With repeated applications of different pastels, very quickly sketched-in, the colors begin to merge optically, creating a woven mesh. This is one of the fundamental techniques every pastelist should know. It can be employed alone or in conjunction with other methods. Many painters praise the combination of a side-stroke application for the first layer, followed by crosshatching for top layers.

Soft Over Hard

Standard procedure suggests using hard pastels in the lower layers since they don't fill up the tooth of the paper too quickly. Once a few layers have been applied, you switch to soft pastels which will stick on top of almost anything. If soft pastels are too thickly applied in the bottom layers, however, it is difficult for the hard pastel to stick to the surface. But not always. I often build up the surface with hard, then soft, then go over the top with hard pastels to feather colors together, then perhaps I'll add a few accents of soft pastel.

It is possible to build up a great number of layers, and only experience will show you how many. I advise you to experiment on scraps of different papers, and to see how many layers you can apply. See if you can put on so many layers that the paper won't hold any more. Vary the pressure of the strokes too. Most novice pastelists are so cautious about not going too far that they fail to go far enough.

Creating colors you don't have

It is often said that the great difference between pastel and oil painting is that the pastelist does not mix colors, but must have a large array of colors from which to choose. While it is true that a pastelist isn't required to do as much mixing, let's not overlook color mixing entirely. At times it is necessary, and often is beneficial.

Suppose a mossy green is the color you want but you don't have a pastel stick of the approximate hue.

Suppose further that these three sticks are all you have available: black, orange and cool green. At first glance your prospects seem rather slim, but armed with a little knowledge and a little patience you can do wonders.

Over a layer of black, loosely scribble some strokes of bright green. Immediately the extreme blackness has been modified and the brightness of the green has likewise been attenuated.

Pure red is the complement of green, and mixing the two colors together will neutralize them. Since orange contains some neutralizing red plus some sunny yellow, it is the right choice to add here. It will knock back the bright green somewhat and the yellowness will retain life in the mixture. Add some strokes of orange over the black-green, leaving the colors unblended.

Repeated layers of green and orange, applied with a light touch, will result in a fairly uniform tone. Personally, I prefer the effect of the broken color in the previous step, but at times the flat color in this step is useful.

Remember that when layering colors, you can repeat the use of any

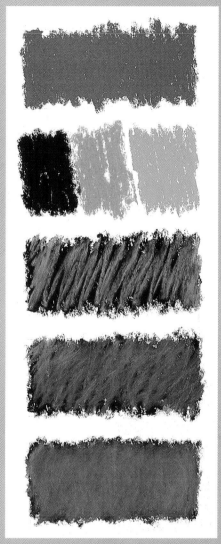

These three colors can be combined in a variety of ways to achieve a great number of different effects, including making new colors.

color at any time. You can use a color more than once in the sequence and the results will be different each time. An example might be: red-orange-brown-orange-yellow. Another sequence might be: blue-violet-blue-green-blue-violet. If the layers are loosely woven together, you can get wonderful results.

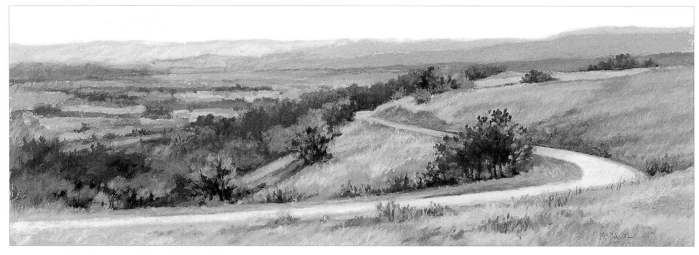

Long and Winding, pastel, 8 x 23" (20 x 58cm)
Paintings with a long format, either vertical or horizontal, provide an excellent opportunity to employ modulation of value or color. Notice how the sky gradually changes hue as it stretches across the horizon. The road also modulates, from orange to blue. Any object can appear dark or light, warm or cool, depending upon its illumination. A panoramic scene permits you to show subtle changes in illumination from one area of the painting to another.

Pastel Dust

There are some who, suffering from asthma, allergies, or other respiratory ailments, steer clear of pastels because of the dust. In the studio, artists who still want to use pastels will use respirators, ventilation systems, and air purifiers with HEPA filters to ameliorate the problem. Working outdoors greatly reduces the problem, but you should still be aware of pastel's dust.

Make sure to avoid blowing excess dust off your painting or easel (and into the air). If I need to remove a build-up of pastel dust from my painting, I take it off the easel and hold it vertically at arms length with my left hand. Then I thump the paper (my pastel paper is usually taped to a piece of foam board). The formal term is a fillip, wherein the thump is accomplished by "the sudden forcible
straightening of a finger curled up against the thumb." This action will dislodge loose particles of pastel, and the dust will be carried off harmlessly into the air. Just be sure to hold your breath for a moment until the particles dissipate.

Likewise, be double sure to hold your breath if you decide you need to blow the dust off the painting. To clean pastel dust off the painting tray of my easel I will use a brush or rag to scoop it onto a scrap of paper, which I then discard.

Pastel is not for everyone (nothing is), but for those with a sensitivity to the pastel dust that can accumulate in the studio, try working outside. Pastel may prove to be a completely acceptable medium to use on location.

Light Over Dark

Another standard procedure entails applying light colors on top of darker colors. This is handy since it mimics the way in which we see. Objects appear as though the highlights and reflections are an additional layer of sun-bathed color resting on top of the object. Because pastel is opaque, you can add light marks right on top of a dark passage. Watercolorists need to adapt to this difference when switching to pastel, but it shouldn't take long. Just remember that it is not necessary to save the white of your paper to produce pale tints.

This is not to say you can't work a dark color into a light area. I do it all the time. It's easier to put light over the dark, and that is the norm, but the reverse works too. There is a greater chance of muddying the colors by adding the dark on top, but with practice it's not much of a problem.

Speed and Efficiency

Speed and efficiency are aspects of painting that attain great importance when painting outdoors. The following method increases efficiency by making full use of pastel's opaque nature. Simply put, you needn't be precise with both edges where color A meets color B. If you carefully paint shape A, you slow down at its edge in order to render the edge correctly. If you then paint color B right up to the edge of the first shape, you must slow down again to avoid messing up the nice

edge you already painted.

Instead, apply the first color so that it goes beyond the edge of the form you are painting. Pretend you are going out of the lines in a coloring book. Now paint the second color up to the first, over the ragged edge so that it cuts into the first color, and creates the form as you would like it to look. Rather than slowing down to render that edge twice (once with each color), you only need to render it once — a great time-saver!

Threepee, pastel, 8 x 12" (20 x 30cm)
This is no recreation of the historic American West. This is a summer camp for kids along the Deschutes River in Oregon. The little campers had not yet arrived and I couldn't resist the design potential of three eye-catching white cones in a natural setting.

New Year's Day, pastel, 12 x 9" (30 x 23cm)
There's nothing like the first outdoor painting of the year, especially when the snow is fresh but the temperature has risen to a balmy 50 degrees. The air sparkles. You're so warm in the sun that you strip down to a T-shirt. You are entertained by the distant thud of warming snow as it drops in clumps from the pines. This odd percussive accompaniment does not show up in a photograph. You have to be there.

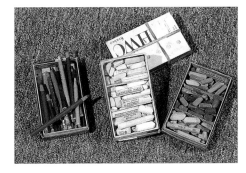

These small boxes fit into my pockets. Note that I don't carry new full-length pencils.

The Outdoor Painter and other People

The Buddy System

Be prudent and plan your outings with a friend. It's safer that way, and the company is nice. If that's not possible, at least let someone know where you are going. Take a cell phone for an emergency, but don't spend all day yakking on it.

Human Pests

Some of us are less sociable than others, or perhaps more self-conscious about our struggling work, or maybe just unable to concentrate with lots of distractions. For whatever reason, people can become the biggest pests of all. Usually the more you talk to onlookers, the more they talk back. If you politely stay silent, they eventually go away. Many painters wear headphones when working in public, even if they aren't listening to music. It just seems like they're aurally preoccupied so people are less likely to engage them in conversation. At plein air events you will see the entire range of painters who talk and those who don't.

Other Commonsense Suggestions

Don't leave trash. Don't set up in a pathway. Follow the country gate rule, which means, "If it's open, leave it open. If it's closed, leave it closed." Also, if you plan to paint at a public park that has a locking gate, make sure you pay attention to closing time, and it is wise to let the staff know you are painting on their grounds.

The Outdoor Painter and Nature

Poison Ivy and Poison Oak

The best "remedy" for all poisonous plants is avoidance. Learn what the plants look like and stay away from them. Before you clomp through a thicket of foliage, look at it. Before you sit down in something, look at it. If you do get a plant rash, you can buy a number of ointments and lotions at the pharmacy that will make you feel better and will clear things up in about two weeks. If you do nothing, healing will take about 14 days . . .

Lyme Disease

So named for the town of Lyme, Connecticut, where it was first reported, Lyme disease is a tick-borne disease. The most common vector is the deer tick, which is smaller than a flea. In areas known to have deer, be especially careful when walking through tall grasses or underbrush. If you wear light-colored clothing, it is easier to spot a little dark tick on a light background (value contrast!). When you return from painting for the day, be sure to examine yourself thoroughly.

Mosquitoes

I have tried many insect repellants, but generally forget to use them, so I try instead to go where mosquitoes don't congregate. For one thing, they don't like wind, so look for a spot with a gentle breeze.

Heat

Stay in the shade when possible: you will stay cooler and it is easier on your eyes, as well as your ability to judge values. An artist's umbrella creates shade wherever you need it, and can be moved as the sun's position changes. Wear a hat with a brim to cut down on glare (sunglasses are not usually worn for painting since they distort colors). Sunscreen is a good idea, and above all, DRINK YOUR WATER. Avoid wearing dark clothing in the heat. You'll cook.

Cold

Outdoor painting in winter is an art and joy in itself. Using some common sense may make the difference between an unpleasant ordeal and an exhilarating creative adventure. With planning, there's no need to avoid nature's quiet season for plein air work. Many artists look forward to the arrival of each winter, and with it another opportunity for working in the snow. I have grown to enjoy winter painting tremendously, and recommend it with enthusiasm.

Seldom will you see classes working outdoors during winter though, since people differ greatly in their tolerance for low temperature. Some folks easily adjust to the cold and are excited about painting a snowscape, while others soon begin shivering and they long for the warmth of the studio.

Consequently, most painters work alone in winter, or with a friend of equal stamina. It is therefore crucial to let someone know your plans when you go out for the day. Bring a cell phone if you have one, and make sure the batteries are fully charged.

Regarding suitable clothing, I find that layering offers the most flexibility and provides the greatest warmth. It is amazing how toasty it can get in a sheltered location with the sun's rays shining on you. At times like these you can maintain your ideal comfort level by peeling off a layer or two. Just be sure to keep these garments dry. Place them in the sun so they won't be cold when you need them again.

A hat or cap will keep your head warm, and proper footwear will help your feet stay warm and dry. If you're working in snow, stand on a piece of cardboard, carpet, or foam: it makes a surprising difference.

As for the hands, which will be your most active extremities, they need to remain warm without being bound up like a mummy. Various gloves and mittens are useful, and some artists like "fingerless" gloves, though I can't seem to stay comfortable in them. I prefer wearing the thin nylon glove-liners, covered with an insulated mitten. I slip my painting hand out of the mitten to work, but the glove liners offer some warmth until I stick my hand back into

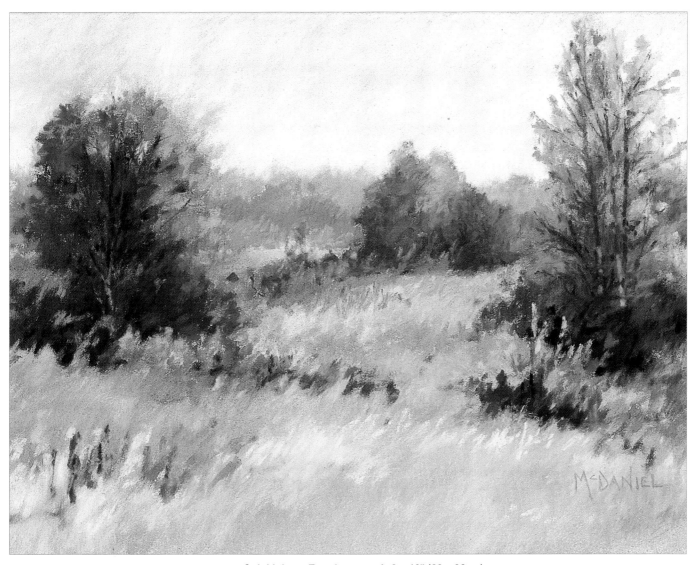

Soft Light on Tuesday, pastel, 9 x 12" (23 x 30cm)
Not all days are clear and sunny nor strikingly stormy. Many have a soft humid light that lies somewhere between the dramatic extremes. I painted this scene while standing beneath a porch overhang since rain was forecast for later in the afternoon. The hazy light was strong enough for me to see intense color, yet there was not much contrast between sunlight and shadow.

the mitten. A jacket or sweatshirt with a hand warming pouch is great. For extreme conditions you may want to try the neoprene gloves worn by divers, windsurfers, or fishermen. Another option is the battery powered or chemically activated hand-warmer. They're lightweight and work well.

Check camping or sports supply stores for a lot of this gear. And take along a thermos when you can — it's good to be warm on the inside too. Remember the lip balm and sunglasses. Although you might not paint with sunglasses, they will certainly cut down on snow glare as you hike to and from the site. Circulation of the blood is how the body stays warm, so periodically step away from the easel and flap your arms while marching in place. It'll warm you and amuse you, and will surely entertain any passers by.

Wind

Wind will affect you in two ways. It can blow your equipment around and it can make your body weary. Lip balm and a scarf are lightweight assets to include with your gear. A cowboy's bandana has many uses beyond serving as a mask when he's holding up the stage. Your scarf can warm your ears, tie items together, wipe up spills, act as a flag or

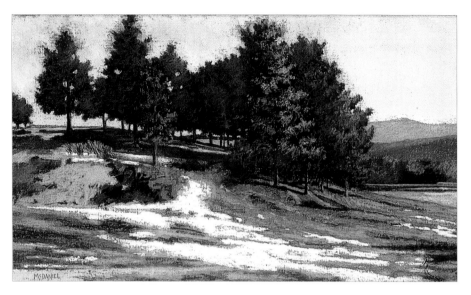

Late Winter, Late Day, pastel, 12 x 20" (31x51cm)

Vermont in March. Areas of bare ground provided a rich russet-colored contrast to the patches of snow. The warmth of the afternoon sun enhanced the color resonance of the scene, and admittedly made my painting experience more pleasurable. A photograph can't transmit the sounds or other sensations that are so much a part of working on-site. There is something divine about cool crisp air on skin warmed by sunshine. Painting outdoors on a snappy winter day, deliciously warmed by the sun's rays, I am reminded of hot fudge on ice cream as I move back and forth between sun and shade, seeking the ideal mix of temperatures.

The author and his trusty thermos. If you are prepared, painting in the snow can be quite comfortable and lots of fun.

Tent stakes, pounded into the ground with a rock, hold the tripod well in a wind. Ropes and bungee cords are helpful too. And be sure to eat a big meal, ha ha.

I use a "ballast bag" with my tripod to help maintain stability. A few stones from the site provide all the necessary weight, and only the empty bag needs to be transported.

Not all days are sunny and pleasant. Every once in a while Mother Nature decides tha painters need to work in the rain or take th day off. At least the restaurants in Rousillo provided warm food and a harmonious atmosphere for discussions on art.

a container, and work as a strainer.

The greatest nuisance from wind is its blustery challenge to the stability of your equipment. A French easel is quite stable, and my choice for windy conditions. But I always carry an empty cloth bag and bungee cord when I go out to paint. Filled with stones or sand, and suspended beneath the center of the easel, it provides useful ballast. When painting with a pochade box and tripod, the ballast bag is even more helpful. Suspend the bag on the cord from the center of the tripod so that it dangles just above the ground to achieve maximum stability.

I've also drilled holes at the feet of my tripod into which I can insert metal shower rings or a loop of wire. The tripod is then secured to the ground with tent stakes.

If a sudden gust of wind takes hold of your painting umbrella it can upend everything it is attached to. For this reason I caution you against clamping the umbrella to your easel. Attach it to a separate tripod (staked to the ground) or take it down if wind is an issue.

Rain and Snow

If precipitation begins to fall, you'll want to protect your pastels and papers first. I have waited out many brief showers beneath the shelter of a bridge, or even a tree, but a prolonged downpour is a different story. Buildings with a covered porch are a great alternative, and provide an opportunity to paint the storm directly without getting soaked. Some artists simply drive to a good spot and work in the car, the steering wheel doubling as a makeshift easel. I like the studio-on-wheels concept (a van or pickup truck specifically outfitted for a painter's use). Some vans have large side doors that allow a broad view of the scenery while the artist stays warm and dry inside. Mine has a lift up tailgate that creates shade or mild rain shelter while I stand at the rear of the vehicle. My supplies are all easily within reach inside my rolling studio yet I still can enjoy a plein air experience.

Darkness

Whether we like it or not, it gets dark

Hints for Working on Location

Easily avoided irritations can turn any outdoor painting experience into a hardship. The self-critical painter may assume it's a problem with his or her artistic ability, when that is not the case. It may simply be a matter of mechanics. Learn to eliminate the little hassles and you'll be free to concentrate on the art.

- *Rule Number One for outdoor painting is to keep your gear light and compact. It's no fun lugging a bunch of weight around and becoming worn out before you begin to paint. Your ability to whittle down the bulk of your equipment will come largely from experience, as you come to learn your own needs. The reason for bringing too much is usually from fear of bringing too little. Time will teach you what is absolutely necessary. If you pay serious attention to your gear-usage during each painting excursion, you will soon notice what items you don't use very often, and therefore what items can be left home.*

- *I like to have equipment with me that I can set up and tear down quickly. I've become very comfortable with my French easel and all that it can do. Likewise, a tripod and pochade box is a versatile combination that is lightweight and stable. Either system can be operational within a few minutes. Whenever you have new equipment, practice setting it up in your studio before going out in the field. You needn't clock yourself, but you clearly want to make sure everything works properly.*

- *I have different equipment setups for different types of painting excursions. My "micro-kit" is quick and easy, and allows me to hike without weight. It is similar to the pocket watercolor set I used to carry with me. With it I can sketch outdoors in full color. I also bring a sketchpad of pastel papers with interleaving between each sheet. I suggest you always stretch a rubber band or two around the sketchpad when it is closed so the pages don't rub against each other while in transit.*

- *For travel by air, I find that a pochade-style pastel box and a tripod work well for me, especially because I can divide the load. I can send the tripod through as checked baggage and keep the pastels with me in the passenger compartment. When I have the luxury of driving my car directly from my studio to a site, I take any or all of the above, or my French easel and a large assortment of colors.*

- *For me, it is a great help to keep my easel and art supplies packed up and ready to go. It's frustrating to search for the right selection of colors and papers as I run through some mental checklist, fearing to forget something critical — while the daylight is perfect and the urge to paint outside is overwhelming. If everything is packed up and waiting by the door, all one needs to do is dress appropriately, pack water and a lunch, leave a note, and take off.*

- *Corot is said to have taken along a square of white linen and one of black velvet when he painted outdoors. He would place them on the ground in the middle distance to judge the relative values of the scene as they existed between white and black.*

- *I usually bring an extra piece of pastel paper taped to its own backing board. It hardly adds any weight at all, but can come in so handy. It gives me the option of starting another painting whether the first one is successful or not.*

- *Ask permission to paint on someone's property. There is an old tradition of hot-air balloonists carrying a bottle of champagne for each flight. Wherever they landed, they would share the champagne with the owner of the property upon which they set down. What a great way to turn potential antagonists into instant friends. I always thought it would be a good tradition to share a bottle of champagne with landowners who graciously allowed us to paint on their property. It is hardly a diplomatic necessity, for permission is usually cheerfully given. I have even been the lucky recipient of cookies and lemonade, which I think would be a grand tradition for landowners to continue!*

- *Advance contact with the landowner eliminates tension, and provides a modicum of security as well. They may even be quite interested in your activities. Courteous behavior on the part of the artist is always a good policy, and occasionally leads to a sale.*

Coit in the Mist, pastel, 8 x 11" (20 x 28cm)
One of the great advantages of pastel is the ease with which you can make adjustments. The ambiance of late afternoon was comfortable and inviting as I began painting under a mostly blue sky. Soon the day turned dark and damp. Details disappeared and the scene changed to a silhouette. As layers of foggy mist shrouded the scene, I added layers of pastel to the painting to depict the heavy atmosphere.

Checklist for Heat

- [] Work in the shade, or use an umbrella
- [] Wear sunscreen and/or insect repellent
- [] Wear light-colored clothing
- [] Wear a hat
- [] Drink water

Checklist for Wind

- [] Take a scarf
- [] Include ballast bag and bungee cord
- [] Use lip balm
- [] Use a separate tripod for umbrella

Checklist for Rain

- [] Find shelter

Checklist for Cold

- [] Take a cell phone with fully charged batteries
- [] Wear layered protective clothing
- [] Keep head and ears warm
- [] Stand on a mat
- [] Take gloves, mittens, or hand-warmers
- [] Include sunglasses
- [] Use lip balm
- [] Take a Thermos
- [] Stay active

Checklist for Darkness

- [] Carry a small flashlight

at the end of each day. The nice thing about painting in the late afternoon is the attractive warm light, along with the long shadows. Also, unlike dawn, when you paint at the end of the day, the essence of the scene tends to get stronger as the hour progresses. Shadows become more pronounced and the magical golden light becomes more intense.

However, the light eventually fails and if you take too much time finishing up the painting or packing up gear, the walk home may result in a twisted ankle. A small lightweight flashlight sure comes in handy when it starts getting dark.

Packing and Transporting

So far we've discussed the preparations for painting on location, but now what do you do when it's time to go home? What is the best way to return to the comfort of your studio with undamaged artwork?

It's all quite simple if you've just gone down the street for an afternoon of painting. It gets increasingly more complicated if you've been out painting for a week, especially if you must now fly back home. For a one-day outing, you'll want to pack up your gear, handle your painting carefully, and head home. Usually it's not necessary to cover the art: while driving, just lay it flat in the car, and take it easy on the turns.

But a plein air excursion of greater duration or distance requires a bit of advance planning. Since a major concern for pastelists is that of smearing the image before it is safely framed, it is prudent to take steps to eliminate this potential problem. Although the surface of a pastel painting is susceptible to smearing from lateral contact, it is fairly stable under vertical pressure. Accordingly, if your painting is leaning up against the base of a tree, a visit from a friendly tail-wagging dog will certainly quicken your pulse. However, you can lay a book right on the surface of an unprotected pastel with little harm, as long as you lift the book straight up without sliding it along the painting's surface.

Transporting Work Safely

With these characteristics in mind, it's possible to safely stack a number of fresh pastel paintings on top of one another for transit. Here's my method: I travel with two or three pieces of

Coast Guard, oil pastel on museum board, 9 x 12" (23 x 30cm)

During a paint-out in Point Reyes, a few of us were working on a bluff when the afternoon wind became increasingly assertive. It was downright pushy, and easels fell over. Fortunately I could drive right up to the vantage point. I propped a door open to create an L-shaped windblock and continued painting in relative tranquility.

***Sur le Pont d'Avignon*, pastel, 12 x 16" (31 x 41cm)**
This pastel of the famous bridge at Avignon survived the return trip from France without incident because I packed it properly. I cautiously taped down the image and the glassine, and made certain everything was held in place securely. There was absolutely no damage to the painting during its long trip from site to studio.

foam board, slightly larger than the pastel papers I intend to use. Along with the paper and foam board, I bring tape, string, and some interleaving paper, such as glassine. Glassine is a translucent nonabsorbent paper that is ideal for layering between unprotected drawings or paintings. It looks like tracing paper, which will also work just fine. In fact, any smooth paper will work well.

Transporting equipment hardly deserves mention here, for it is merely packed up as it was for the trip out. Nonetheless, remember to wash your hands once you have arrived home, and check your gear and clothing to make sure you haven't picked up any little hitchhikers. Also, go through your materials and replace colors or supplies that need replenishing.

Although pastel, if unprotected, can be considered fragile, it is easily protected with a little simple planning. That done, pastel reveals itself to be wonderfully portable, with a full range of color, and suitable for a wide range of styles. It is an ideal medium for taking into the field, whether for quick sketches or for complex outdoor paintings.

Air Travel

When you travel by air, it's a good idea to make a list of your supplies before you leave. In the unlikely case your baggage is lost, damaged, or confiscated, you may be able to get compensated. Bring something that indicates you are an artist so it is easier to claim that your art supplies are your tools. If the whole purpose of your trip is to paint, then the protection of your art supplies is extremely important.

Don't worry too much if checked bags are ever misplaced. Most airlines will deliver them to you when they are found—even if they must be flown by another carrier and then driven to you at your final destination in another state. In spite of knowing that nearly all misplaced bags are found and delivered to the rightful owner, the delay is still a stressful nuisance. Avoid packing any irreplaceable items in luggage that you plan to check. Carry on the important stuff.

There are divided opinions as to traveling with art gear: carry-ons versus checked baggage. The advantage to a carry-on is that the bags remain in your possession and you know they'll be treated gently. Also, you are present

to re-pack if the bags are opened for inspection. Since you will be carrying the weight around, you'll be encouraged to consolidate your supplies. If, however, you decide to check your baggage through to the end of your flight, take a few precautions. Pack everything securely and simply. Use plastic bags where you can and put all the gear into a big garbage bag. Remember that a new set of pastels will look like a package of bullets in an x-ray machine. It's safer to travel with partial sticks and broken pieces. One travel note worth mentioning: Pastels don't contain flammable solvents and are not considered hazardous by airport officials.

Along with formal identification, always travel with artist identification too. Bring business cards, a show announcement, or photographs of your work. They may prove indispensable when traveling or when seeking permission to paint on private land, and may come in handy in conversation as a marketing tool.

Transporting Work Safely

While painting on location I use one of the foam boards as a backer board for my work. When a painting is finished, or when it's time to pack for the return trip, I begin by taping the image (face up) to one of the foam boards. Masking tape works fine — this is temporary packaging.

Next I tape a piece of glassine directly on top of the painting, making sure I don't smear the image while laying the interleaving down. I find the safest method is to secure one edge of the glassine and let the rest of it roll down onto the painting.

After I carefully lay the glassine down on top of the painting I tape the edges to the foam board.

Now I'm ready for the next painting, which I cautiously tape down right on top of the previous layer.

This is followed by the next piece of glassine, which I also tape down. These steps are repeated until the artwork and interleaving are securely taped to the foam board.

Finally, it's time to put the second piece of foam board on top and tape the whole sandwich together so that it cannot move. Okay! It's ready for the suitcase. As long as nothing can slide around laterally (which is the purpose of all the taping), the images will remain intact. I have transported up to a dozen fresh pastel paintings this way with good results. Back at the studio, after carefully reversing the packing process, it's easy to touch up any minor smudging that may have occurred.

Out On Location

Painting is always about relationships and intervals. As you study the elements in the landscape, remember that it is the arrangement of these factors within the composition that is important, and not the elements themselves.

Once I've arrived at a suitable painting site, I like to plop everything down on the ground and stroll around with my sketchbook and a viewfinder. Usually I don't need to go very far. The whole world is exceedingly paintable, as long as you are visually engaged and open to impressions.

If I don't see anything right away, I take a moment to relax (maybe the perfect motif is right in front of me but I missed it because I was looking too hard!) Some artists like to meditate

"I am so anxious to set to work, especially in the open air."

— Vincent van Gogh

or at least take a deep breath to center themselves, and to be receptive to inspiration.

Rather than having to hike far in order to find suitable subject matter, my usual problem is that I see too many possibilities. Make no mistake. This can be just as lethal as seeing no

possibilities at all. A selection needs to be made, so I just choose a single scene, and leave the others for another time.

This is where a viewfinder proves most valuable. Since the raw landscape has no boundaries, things can get mighty confusing if you're not mentally prepared. A viewfinder helps define the boundaries, or format, of the motif. The boundaries, where the image actually ends, are crucial in formulating the composition.

When I look through the viewfinder, I am searching for a scene that interests me emotionally and aesthetically. I explore various configurations — horizontal, vertical, square — and I consider whether the main activity will occur to the right, the left, at the top, or the bottom. Paintings are held together by the interplay between positive and negative space, and also by the relationship between the active areas and passive areas (rest areas). Without rest areas, everything is active, everything is emphasized. When all is emphasized, nothing is emphasized. The initial placement of the big shapes (positive and negative) will set the tone for the design. Always give attention to the negative space, it is the portion of a

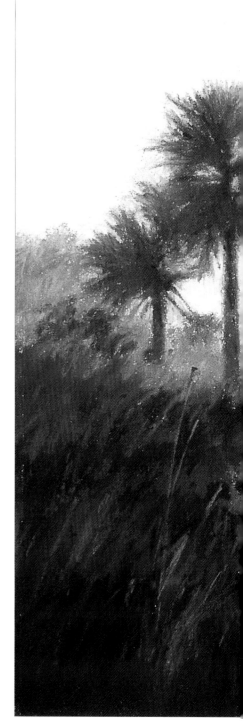

Neon Palm at Dusk, pastel, 12 x 16" (30 x 41cm)
Almost a nocturne, this is a very simple concept of capturing the scene in silhouette as the light was fading. Speed is important when racing the sun at the edge of night.

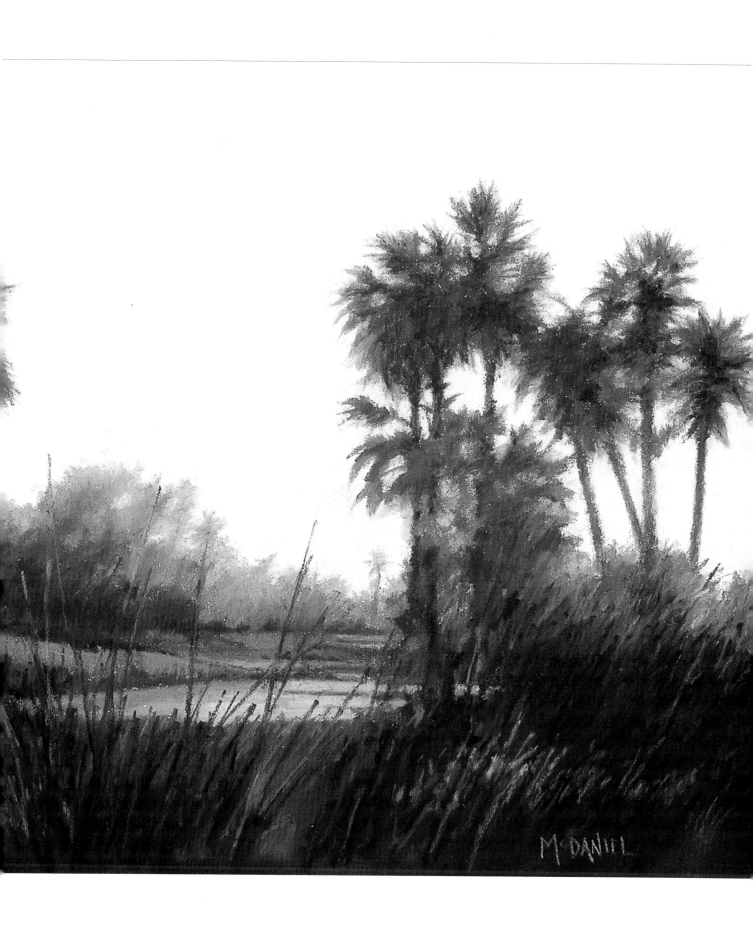

Lighting makes all the difference in the world, as these four shots of the same scene illustrate. Left to right: early morning light, late morning light, early afternoon light, and late afternoon light.

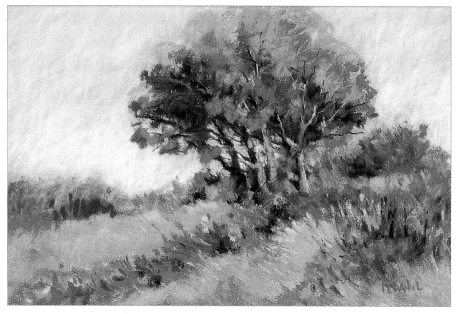

Los Robles, pastel, 6 x 8" (16 x 20cm)
One afternoon, immediately after class had concluded, I sat down on the veranda and studied the oaks on a nearby knoll. Someone brought me a glass of wine along with some cheese and crackers and I eased into the painting as a few students joined me. Ah what a blast! I am reminded over and over again that I truly enjoy the process of painting on location, even when I am relaxing in the lap of luxury.

Note how I stretch a rubber band around the closed sketchbooks to keep pages from rubbing against one another and smearing the drawings.

painting that breathes. Utilize the components of the landscape that reinforce the power in your design.

Painting is always about *relationships and intervals.* As you study the elements in the landscape, remember that it is the arrangement of these factors within the composition that is important, and not the elements themselves. Intervals, or the spaces between objects, are crucial to the rhythm of a design. Uniform spacing creates monotony. Variety in spacing, like syncopation in music, adds much more life to a painting.

The "law of unequal measures" refers to the practice of avoiding a 50/50 distribution of elements in a painting. A composition is weakened if it is half dark and half light. Let one dominate. Likewise, choose a major portion and a minor portion when orchestrating components such as warm and cool; active and passive; bright and dull; and so on. In each case, a stronger, more engaging design will result if you allow one element to dominate, with its opposite in a subordinate role.

In arranging a still life you have direct control over the placement of the objects you plan to paint. You can move things around until you have a composition with staggered heights, interesting intervals, diversity in shapes, and a pleasing distribution of colors. You must consider the same principles of design when planning a landscape, yet it's not as easy to pick up and move a pine tree as it is to reposition a bowl of fruit. However, you can change the relative size and position of landscape elements by moving your own position.

As you walk closer to that pine, it seems to get taller; as you move to the left, the space between the tree and the boulder increases. Standing or sitting can change the shapes in the motif dramatically.

Planning on paper

While the improvisational artist may start right off painting in color—and that is a stylistic choice with which I have no problem—they are usually very experienced painters who thrive on the increased uncertainty of working without a preliminary sketch. Most other painters, however, will find that the more efficient procedure involves the use of a sketchbook. Do some planning on paper!

When I was younger and less patient I thought that drawing would slow me down. I wanted to get right to painting: right to the color. Since then I've learned that many of my compositional concerns are answered in a few minutes of drawing instead of during time-consuming revisions throughout the painting process. Rather than decreasing my passion for painting, the "extra step" of drawing works to warm me up; it actually increases my fascination for the topic, like an aperitif enhances my appetite before a meal.

Preliminary sketches enable me to explore several ideas quickly. I can test out different formats or experiment with value schemes without investing much time. It is similar to preparing an outline before writing a book. It puts you on the track of thinking about the *total* composition. I've also come to appreciate the preliminary sketch for yet another reason. Drawing makes me

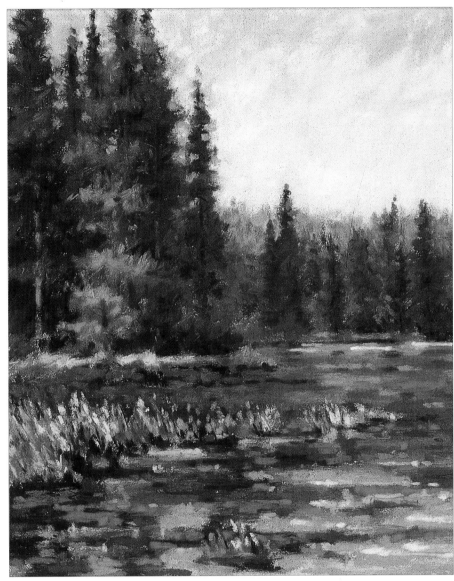

***Sparks Lake**, pastel, 8 x 6" (20 x 16cm)*
On the final day of a workshop I arrived at the site early and started this painting before class began. I noticed the scene the previous day and had made a brief sketch of the subject. It is a small piece, only 8 inches tall, so my pochade box and tripod were perfect for the task.

Some of the sketches served as roadmaps for paintings. All of them are direct responses to the subject and my first heart/mind/hand/eye connection to the motif. The drawings are a visual record of an artist's investigation of a specific topic.

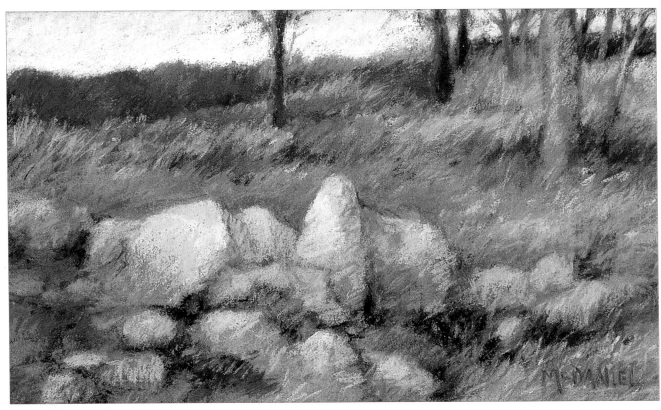

El Dorado Sundown, pastel on hand-made pumice board, 5 x 9" (13 x 23cm)

A few years ago I was driving to a plein air event in the foothills of the Sierra Mountains. On the way, my truck broke down in an isolated area and I was stranded for a day. When I eventually arrived at the paint-out in a rental car, I was crabby and feeling sorry for myself. It was late in the day and the light was beginning to fade, but I pulled out my supplies and began painting the first thing I saw. Before long the tragedy of a thrown rod was replaced by the struggles of plein air painting.

When it Rains it Pours, pastel, 8 x 16" (20 x 41cm)

Although this appears to be snow, it is actually salt at the Morton Factory. I was especially attracted to the long lines of the roads as they divided the space into geometric patterns.

Monhegan Magic, pastel, 10 x 15" (25 x 38cm)

My first visit to this rustic island was at the invitation of fellow artists from the Woodstock School of Art, who had been taking painting trips to Monhegan for decades. Each morning we'd venture out onto the little paths that criss-crossed the scenic island and find a spot to paint. At the end of the day we'd gather for a happy hour of show-and-tell before dinner. There was no television at night, and some of the cabins had no electricity. The next morning we'd embark upon another day of painting. For Monhegan Magic *I found a spot where I could set up my pochade box just to the side of a trail. A few people passed by, stopped briefly for a friendly word, then hiked on.*

more familiar with the subject I plan to paint. It makes me focus on my own interpretation of what I plan to paint. I see the marks I make. I see the intervals I create. Before I begin painting, I can look at the real scene and I can look at my own interpretation of the scene. I begin to see my own fingerprints on the motif.

When first looking at a scene, I look for a variety of shapes and values. I seek out contrast in values, and hope to find a reasonably wide range of dark and light. Stormy or foggy days will reduce contrast considerably, but that is the specific charm of these conditions. I look for the characteristics of light that define each particular scene.

In addition to strength of value, I hunt for shapes that have individual character. There is not much variety in a row of walnut trees that are of equal size and height. But the composition is much improved if there is variety in the intervals (negative space) between the trees.

Still scoping out the scene, I ask,

"Where is *it* happening? Foreground, middle ground, or background?" Most frequently the middle ground is the setting for the center of interest, but of course there are exceptions. The middle ground is a good location because the background can be painted simply, in softer focus and with less contrast, and therefore won't compete with the center of interest. Likewise, a good foreground will lead the viewer into the scene without distracting from the main activity in the middle ground.

In order to avoid such foreground conflicts, refrain from painting the eyelashes on the bumblebees that buzz around the wildflowers that grow at the

base of the rock wall on the near bank of the stream that runs in front of the grist mill that is the subject of your painting.

You might wonder, how then to paint the foreground. There are two choices, and each one depends upon your own eyes. If you focus on the bumblebees, ask yourself (without raising your gaze to the mill), "What does the mill look like? What does the background look like?" It will hardly be more than a vague collection of shapes, with little to no definition. No problem. Paint this as if it were a still life and concentrate on the bees and the wildflowers. The mill will quietly blend

look at your sketch again. Make adjustments to your design if necessary and then get ready to paint. I am in the habit of jotting down the time and date I begin a painting, along with occasional notes about the scene. I write these notations in the margin or on the backer board. If the painting requires a return trip to the site there is no question about the original time of day.

To begin, I determine whether the painting will be warm or cool, dark or light. I start with a selection of about ten colors for my initial work, including a reasonable range of values and temperature, but I know I'll be adding more colors as I go on.

Working with only a handful of pastels will speed up the painting process since you won't spend so much time hunting for colors. Starting with a limited palette will also help you remain focused on the color harmonies of your initial concept.

If I start with a dry wash or a fluid wash, I apply it rapidly, and then proceed to block-in my fundamental shapes. I begin with four or five main shapes and stay away from details. Since I normally build up my paintings in layers I like to put in some wacky colors along the way, knowing I may either cover them up or allow little bits of them to show through between the strokes of subsequent layers.

Changing conditions

There are different approaches to take when confronted by the changing personality of weather and outdoor light. Some painters strive to capture a transient moment by portraying specific lighting effects. It is therefore crucial to record the patterns of light and shade in the preliminary sketch for reference. That initial perception must be held in

into the background, allowing the emphasis to remain in the foreground.

Now, focus directly on the mill. Holding your gaze there in the middle distance, ask yourself (without looking down at the bees), what is happening in the foreground. Most likely you will observe that there are shapes in the foreground, that the shapes possess contrast, and some of the shapes seem relatively large when compared to that tiny mountain in the distance. But you can't really tell what those foreground shapes are. However, indistinct as they may be, they anchor the front of the scene.

Such a foreground can be rendered loosely, with gestural strokes and a few hints of activity—but nothing so strong as to call undue attention to itself. The viewer remains free to traverse the nearby space unimpeded and to seek out the center of interest in the middle

ground.

Corot had a great bit of advice for landscape painters. He said whenever you are painting a scene that includes deep space, refrain from painting any object closer to you than about 40 or 50 feet. That is, let the bottom of your composition correspond to a point in the scene that is 40 to 50 feet away. At that distance you can't tell if the bees even have eyelashes so you are less likely to try painting them.

When a scene resonates with you, make a value sketch or a few thumbnail sketches to establish the position of light and shadow. Squint as you look at the scene. This will simplify your view of the motif by eliminating detail and reducing the number of values. Squint periodically throughout the painting process whenever details become distracting.

Set up your gear quickly and then

memory, aided by the sketch, and called upon throughout the day as the painting develops. Many artists believe it is best to stick with the earlier impression since it is what attracted you to the scene in the first place.

Others prefer to adjust the lighting during the painting process, creating a final image that is closer to the way the scene looks at the end of the painting session. Either approach will work, and you needn't work the same way for every painting. Some painters start with a general indication of the lighting and become more specific as more of the image is completed.

With experience painting outdoors, artists become adept at predicting how the light will change in an hour or two, and try to set up and begin working before the lighting is absolutely ideal. That way, they hope to be an hour into the painting when the light catches up to them.

Remember too, that some days start out sunny, then become overcast, or vice versa. Then you must decide whether to adjust the painting to the new conditions, or consult your drawing (and memory) to stick with the original plan, even though the scene directly in front of you has changed dramatically. The two other choices are to return to the site when the original conditions return, or to determine you have recorded enough information to complete the painting elsewhere.

The most difficult scenes to paint are on days of constantly changing weather conditions. I remember one such day, while at a paint-out in the Sierra Nevada foothills. The morning dawned crisp and sunny so I began my pastel with intense colors and a strong pattern of sunlight and shadow. After I'd been working an hour, the sky began to cloud up. Within a short time there was no blue sky visible at all. I decided the gray was here to stay, and I chose to tone down my colors and continue under the now-gray sky. After making all my adjustments and becoming accustomed to my muted scene, I noticed a little patch of blue on the horizon.

Within fifteen minutes the entire sky had cleared and bright sunshine

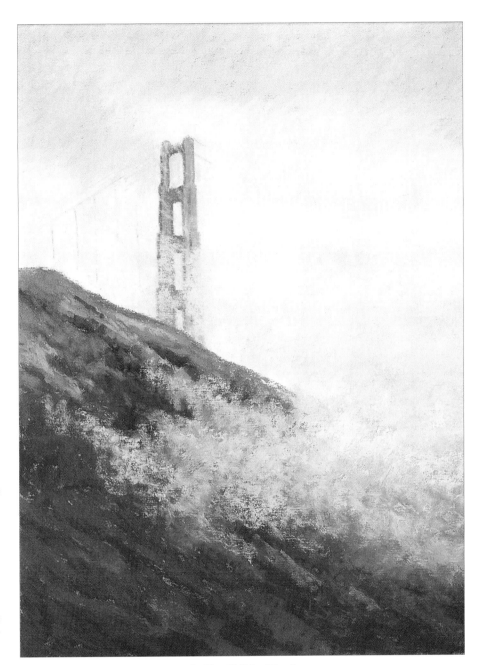

Golden Gate, Advancing Fog, pastel, 11 x 8" (28 x 20cm)
After a short hike to this dramatic viewpoint, I made a brief compositional sketch and started painting the orange tower of the bridge. At first I was disappointed as the fog began to shroud my view. I couldn't finish the bridge and I was getting cold. But soon I came to appreciate the beauty in the fog and realized its importance to the scene. Besides, I couldn't stop the fog anyway.

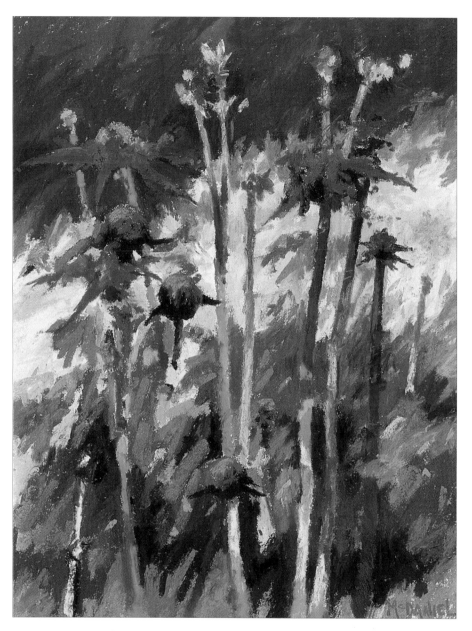

returned, gloriously illuminating the view in front of me. The scene looked gorgeous, but my painting was all somber and dull. Not wanting to abandon the fight, I began to adjust the colors again. One of the advantages in pastel is that these types of changes are possible. This time however I made sure to glance skyward occasionally. It took a while, but I gradually was able to restore the image to its initial sense of sunlight and shadow. Then, from out of nowhere, a little cloud appeared. It must have been the scout. Soon the entire herd arrived and eventually it began to sprinkle. I chalked it up to "one of those days" and went back into town for lunch.

As you build the image, step back periodically to view its progress. A short distance of 8 to 10 feet is sufficient most of the time. When the painting is closer to completion, walk back 50 feet, then slowly advance toward the easel, looking at the image from various distances. This is a great way to judge the merits of the composition.

Because pastel is an opaque medium, there is no harm in working a little darker in the beginning stages, allowing the addition of highlights later. It is easier to lighten a dark than it is to darken a light. Highlights, if applied on top of previous colors, are able to cover them completely. Strokes of light colors that rest on top of dark shapes seem to replicate the way we see.

I take a lot of breaks when I work. They are usually short breaks, only a

Detail
I particularly enjoy the vibrancy of soft pastels for the top strokes of a painting. They retain their purity without mixing with the colors beneath. After building up a few layers of pastel, the surface can become quite painterly.

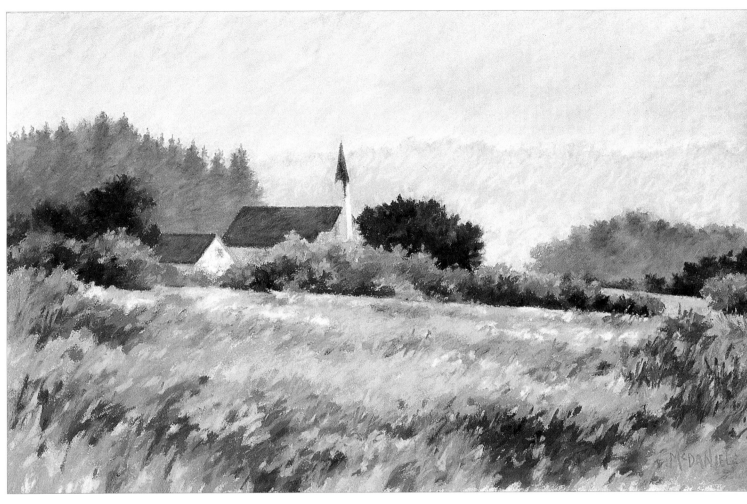

***Mendocino Sunday Morning*, pastel, 12 x 16" (30 x 41)**
The background appears distant because the colors and details are muted. The foreground field of grass holds its position through scale and contrast, yet there is nothing so distinct as to pull attention away from the middle ground where the center of interest resides.

minute or so, because changing light is always a concern. Yet it helps me retain my energy if I step away from the easel now and again, to walk around and gently swing my arms. It is a good way to keep tension from building up, and I find that a relaxed body fosters a relaxed mind.

I try to keep the image loose and fresh for the longest time possible. That way I remain open to change, and can take advantage of surprise possibilities. Eventually I get to the point where I begin to perceive a sense of place in the painting itself. That is the fun part for me. I want to enter the painting and walk around in it (this doesn't work quite the same with seascapes, but since it is only my imagination, I walk around on water).

Now the mature concept of the composition is clearer. I know what I need to do in order to finish the painting so I proceed with vigor. Usually the final design is very close to the concept I had a few hours earlier, with subtle modifications incorporated along the way. Sometimes it is a variation that grew out of the original composition, and sometimes it is a surprising mutation. In either case I try to finish the painting with a fresh touch. I'm careful not to do too much when I am fine-tuning. I've seen many paintings in workshops that begin with so much verve, develop with grace, and then perish from overwork in the final moments. What a shame. We must endeavor to find the proper balance between *finishing and noodling*. Make

your visual statement, then relax. No need to prattle on after your point has been made.

I would be remiss if I neglected to say that some days nothing seems to work. I spend hours working and come home with nothing. The painting may have been a success early on, but somehow it got away from me. All I can say is that failure is also part of the process. Our failed attempts provide the best opportunities for learning and growth. It all goes with the territory, and perhaps plein-air painting is like fishing, in that we go out expecting success, but don't always return home with something worthwhile. Nonetheless, we go out again and keep trying. After all, a bad day fishing is better than a good day at the office.

Art in the making My Basic Layering Technique

My basic layering technique starts with a loosely applied layer that only covers a form partially. The next layer is loosely hatched on top of the first, concealing some strokes and leaving others visible. With repeated applications of different pastels, the colors begin to merge optically, almost like paint being mixed on the palette.

This is one of the bread-and-butter techniques that prove so useful to pastelists. It can be employed alone or in conjunction with other methods of application.

2 My initial drawing

1 Author at work on *Eagle Rock*

"This is one of the bread-and-butter techniques that prove so useful to pastelists. It can be employed alone or in conjunction with other methods of application."

5 *My next layer in the sky provides warmth at the horizon, and I add a blue layer to establish the semi-dark portions of the foliage. Using some warm and cool colors I begin to suggest the effects of sunlight on the rock and meadow areas.*

3 I made the value sketch a year or two ago and generally this would be all I need to begin painting. However, I decided to make a more detailed drawing to become more familiar with the motif and to record the value relationships among the trees, rock, and meadow. On Monday afternoon I set up my easel and leisurely worked on the drawing. I began the painting at approximately the same time of day on Tuesday.

4 Using the edge of a hard pastel, I begin with faint sketch lines to provide a guide. Then I use broad strokes for the ground and foliage, and then apply hatching strokes in the sky, still using hard pastels.

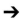

6 Gradually I build up the layers. In the sky I've added aqua and blue violet, keeping the values very similar. Turning to medium soft pastels, I add pink to the meadow — planning to modify the colors as I proceed. Although the image still looks rather sloppy, I am beginning to construct the texture of the undulating leaves.

7 Pale violet defines the horizon here, and I work another layer of aqua into the sky. It's okay to repeat a color after you've used it once — in fact, it can be a very good thing to do when layering. Now that the placement of forms and basic value patterns are established I can begin refining shapes, and I use softer pastels as I progress. Each additional layer helps weave the colors together for greater variety.

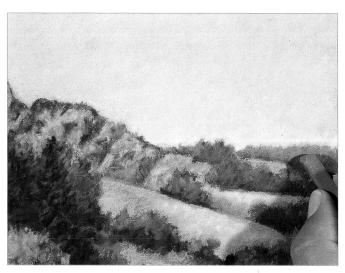

8 *I usually re-establish the darks at this point, working in stages and not completing any one area with a single dark color. Sometimes I put in an unusual hue, knowing I will cover it up later, but that it will help modify the character of the top color. For example, much of the pink in the foreground will be overlaid with green, but the pink will modify the character of green. You can leave the sky aggressively crosshatched, or continue adding layers as I've done here in order to create a uniformly peaceful effect. By using several different colored layers of the same value, it is possible to create a sky with a slight shimmer — one that portrays the luminosity of the heavens. After all, the sky is the light source in landscape painting.*

9 *Here I'm using a pale blue hard pastel over softer passages to mute the distant forms and push them back into space. With a light touch you can vary the amount of pigment left by the stick, depending on how hard you press.*

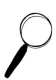

Actual size detail.
The smooth treatment of the sky provides ample contrast to the roughness of the rocks and the active strokes of the foliage.

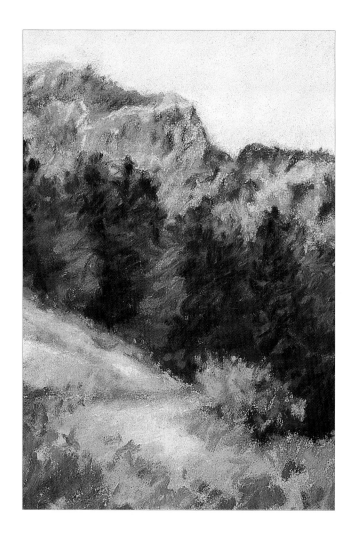

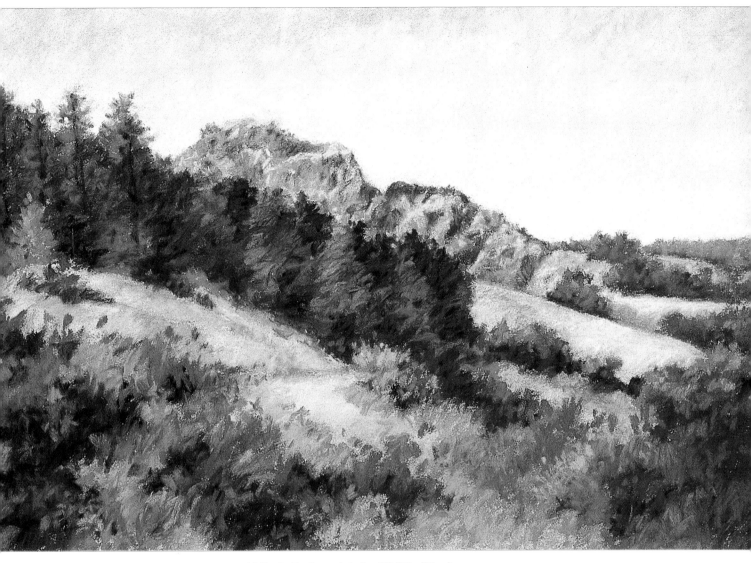

11 **Eagle Rock, pastel, 8 x 12" (20 x 30cm)**
*The major shapes in this scene slant down
to the right. To compensate, I built opposing
directional strength through value and
form. Note how the buff-colored patches
of meadow recede upward to meet the
slope of the rock.*

*Since this view of Eagle Rock is one I can
see from my own land, I have the luxury
of painting it over and over again in various
lighting or atmospheric conditions.
Sometimes a storm or heavy fog will make
the rock disappear altogether. The raking
sunlight of early morning and late
afternoon is particularly appealing, for
it accentuates the texture of the rock.*

Examples Basic Layering Technique

Pyramid by the Bay, pastel, 9 x 11" (23 x 28cm)
The unmistakable skyline of San Francisco is softened by characteristic fog. The pyramid is the main element of the composition but I particularly enjoy the interplay between the small dark vertical shape at the right edge of the painting and the similar light shape between the buildings at left.

Detail

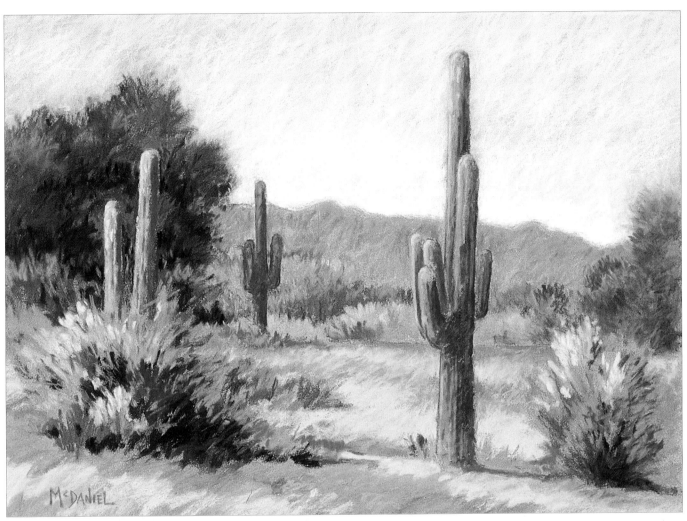

Hot Pickles, pastel, 9 x 12" (23 x 30)

The hot dry sun falling on the cactus elicited a color scheme based on emotion rather than direct transcription. I developed the image by weaving layers of bright color together. Originally my plan was to add more muted colors on top but as the painting progressed I decided I liked the energetic power of the bright colors.

Detail

Art in the making Pastel on a Colored Ground

Pastel papers come in many colors, partly because the pastel medium is so opaque that it can cover vivid hues easily. Unlike transparent watercolor, pastel doesn't require the white of the paper to achieve light passages. In fact, black paper can also be used to great effect with pastels. Colored paper is extremely useful for quick sketching on location, since the paper's color can serve as the middle value, and you can effectively depict a scene with just a few colors, as in El Capitan, page 78.

Colorful paper instantly sets a mood. You approach a painting differently when working on lime green rather than white. Even if you completely cover up all the green, its influence will have persisted throughout the painting process. If bits of the colored ground are allowed to show through in the final image, it often provides a unifying color harmony in the painting.

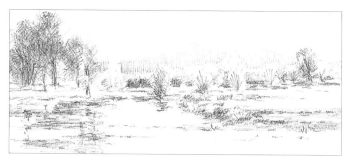

1 *My preliminary drawing is simple. Its main purpose is to delineate the contour of the mountain, set the position of the main elements, and record their relative values.*

"Colored paper is extremely useful for quick sketching on location, since the paper's color can serve as the middle value, and you can effectively depict a scene with just a few colors"

4 *In a matter of moments I have laid the foundation. It's not hard to alter the composition at this early stage. First of all, there isn't much pigment on the paper so adjustments are easy. Also, I don't have much time or emotional energy invested so far—it won't bother me at all if I need to move a tree.*

2 On a brick red piece of paper I began "tagging" location marks with a hard pastel. You can see a few of the position lines that indicate the height of various objects and you can also see a faint outline where I first started the mountain.

3 Continuing with hard pastel I blocked in the large areas using side strokes. This is a very good way to cover the paper quickly.

5 Satisfied with the basic design I start adding scribbles of color on top of the preliminary shapes, building a little textural interest as I go. Note how the same color pink is used in both the sky and the mountain.

6 More layers in the sky pull it under control and help to separate the sky from the mountain. Meanwhile I continue to add kinetic dashes and scribbles to the trees.

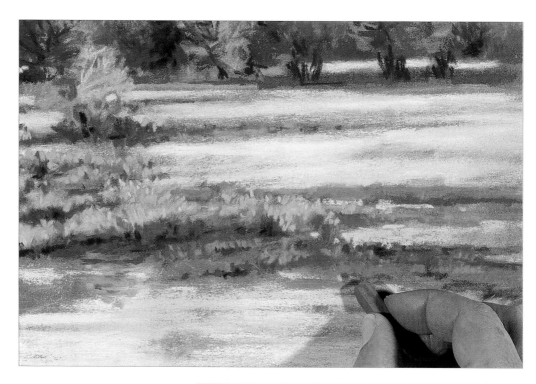

7 *I usually set aside a stick of pastel that approximates the color of the ground. That way I can add back some background color after it's been covered up (it's almost like an "undo" key on a computer).*

Actual Size Detail
Shows strokes on trees, water

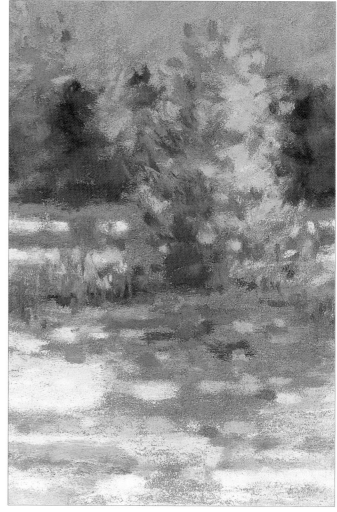

"Colorful paper instantly sets a mood. You approach a painting differently when working on lime green rather than white."

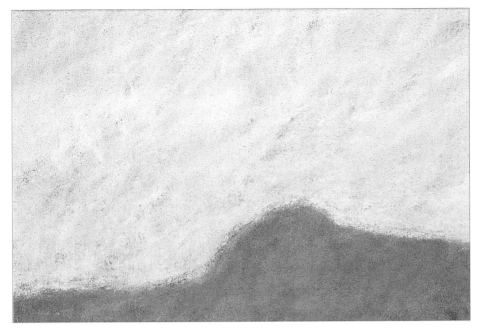

Actual size detail
Here you can clearly see the red of the paper, yet it does not overpower the colors of the sky and mountain. White paper would certainly present a different outcome.

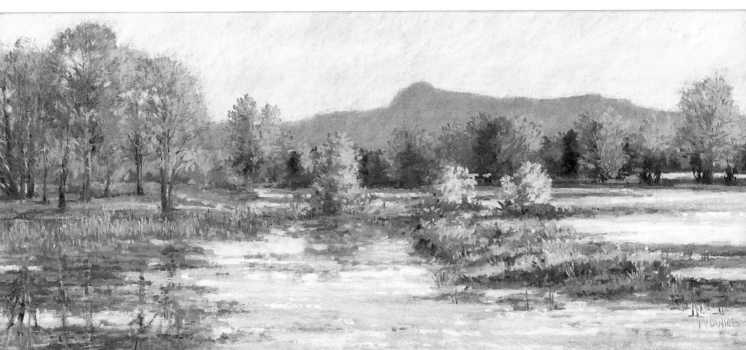

8 *Laguna de Santa Rosa*, pastel, 10 x 24" (25 x 61cm)
The Laguna de Santa Rosa is a 250 square mile watershed in the heart of Sonoma County between Sebastopol and Santa Rosa, California. Concerned citizens have worked hard to preserve and protect the laguna, and it has become a popular resource for many artists, several of whom paint there regularly, and are known as The Laguna Painters.

The completed painting has an overall warm tonality due in part to the color of the paper. Although the amount of paper showing through is not extensive it still has an impact on the temperature of the composition.

Examples Pastel on a Colored Ground

El Capitan, pastel, 9 x 12" (23 x 30cm)
The color of the paper provides the middle value. All I added were a very dark (almost black) brown and a very pale (almost white) tan.

Totem, pastel, 10 x 6" (25 x 16cm)
How would you like to have one of these in your front yard? I don't know the symbolism or the history of this particular totem. I just see an incredible accent to the landscape. I used a red paper that pokes through the green foliage in places so that the red of the totem isn't completely isolated from its environment.

Art in the making The Dry Wash Technique

Although colorful paper adds pizzazz, its uniform hue can be disconcerting to some artists. If too much of that one color pokes through in the distant hills and the nearby flowers, some of the illusion of depth is compromised. Also, a pale-colored paper may make an outstanding background for the sky but not the forest, and a darker paper may suit the forest but not the sky. Many artists resolve these concerns by toning their papers selectively.

A dry wash is a simple yet effective technique that offers great flexibility for the pastel artist. It is easy to do and works on practically all surfaces.

The artist on site

One day while driving a familiar route, I was halted by some road construction. I glanced to the side and saw a marvelous house next to a vacant lot. I had my painting gear with me so I made my own detour. I like the textural contrast of a building with its hard edges softened in places by foliage. The rectilinear houses appeared to grow right out of their surroundings.

As I began my preliminary drawing, I heard a drummer practicing to recorded music in the garage. I smiled with the thought that while I worked I was accompanied by music from little pink.

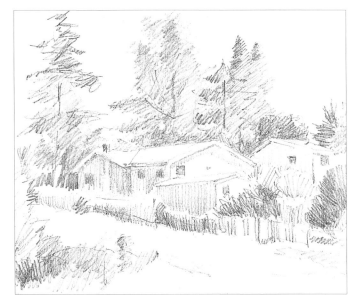

1 With the help of my viewfinder and a few quick thumbnail sketches, I settled on a composition and spent a few minutes with this value sketch. I particularly like this view in which the buildings seem anchored into the slope.

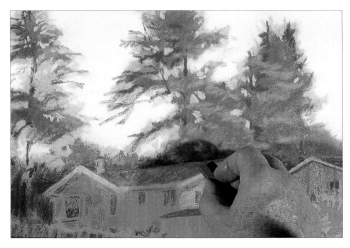

4 Here I am using hard pastels to clarify the edges of the building, and also to suggest branches in the trees.

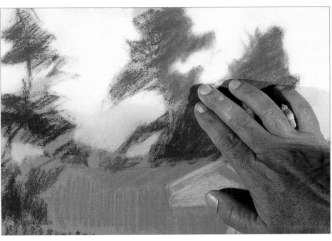

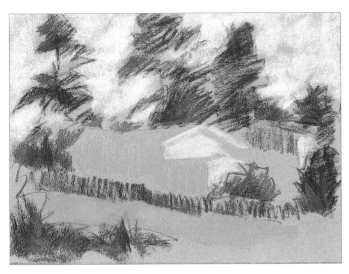

2 *Half sticks of soft pastel work wonderfully for starting a dry wash because the color is easy to spread. I blocked in the major shapes using the side of the stick.*

3 *Next, I rub the color into the paper, minimizing individual strokes and creating a flat tone. You may prefer to use a piece of cloth, especially if working on a rough surface, such as sandpaper.*

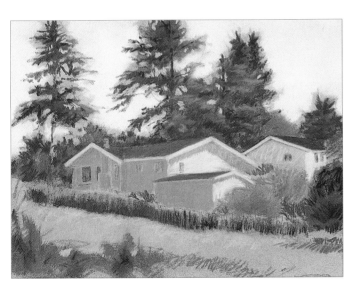

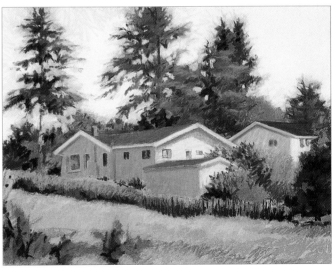

5 *At this stage the personality of the house is already evident, yet I haven't really been too precise in my rendering. I enjoy the relationship between the pink and green buildings. Clearly the pink is dominant, yet the green acts as an effective transition between the pink house and the background foliage.*

6 *After strengthening the darks, the value range is established. Now I can spend more time on the details, seeking the balance between clarity and simplicity. This is a painting, not a blueprint for construction.*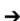

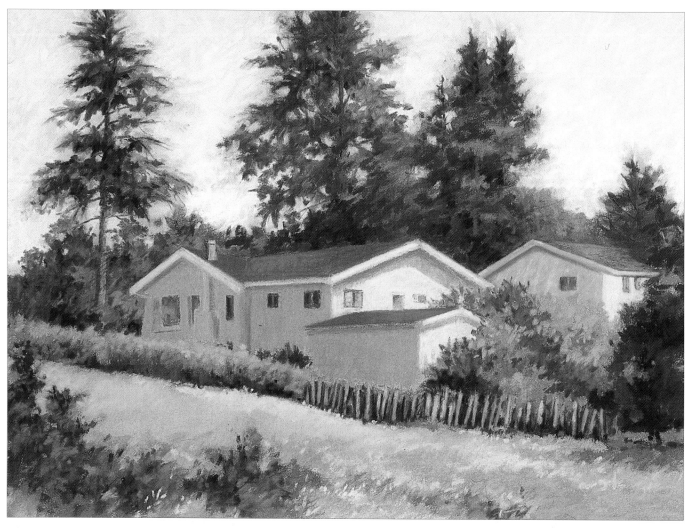

7 *Penngrove Pink*, pastel, 12 x 16" (30 x 41cm)
The foreground field did not require too much work. It serves as a visual entrance to the painting and establishes the slope of the terrain. Notice how its color modulates toward the green at the left, setting up a affinity with the building on the right.

Actual size detail
Some color in the fence echoes the color of the second house and of the sky. The fence is treated loosely, almost as if the pickets were starting to return to their earlier incarnation as a tree.

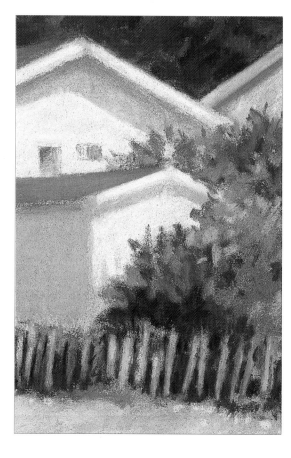

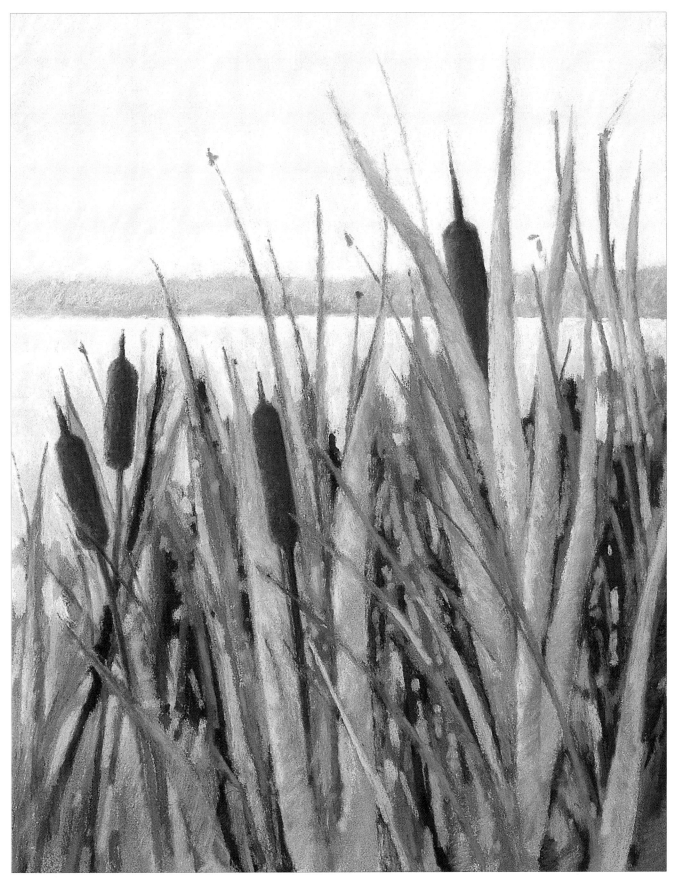

Cat Tails, pastel, 16 x 12" (41 x 30cm)
*Plenty of water was available but my paper wasn't compatible with water.
I blocked in the design using inch-long chunks of soft pastel, then rubbed
the pigment into the paper to create the major shapes of sky, distant shore,
water, and reeds. Then all I did was add pastel strokes to define the shapes.*

Art in the making The Turpentine Wash Technique

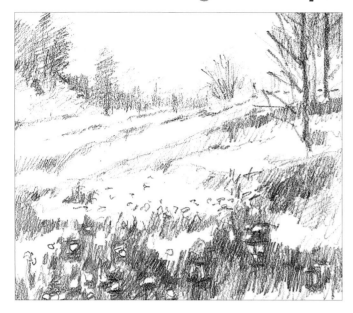

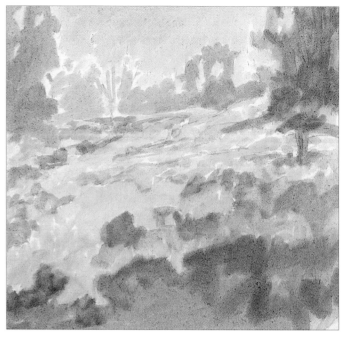

1 *As I produced the value drawing, I concentrated on the abstract shapes created by the masses of flowers rather than individual blossoms. I made a few notations of "floral activity" in the foreground, but nothing precise.*

2 *Mixing up some turpentine-diluted oil paint on my palette, I brushed in the major shapes using a bristle brush.*

A nother procedure for selectively toning your paper involves the use of turpentine to create a thin wash. You can use oil paint, diluted with turpentine, and applied to the paper with a brush, or you can block in colors on the paper with pastel, then use a turpentine-soaked brush to spread the colors around, as I did in Demonstration 6, page 98.

A variation you might want to try is to use an atomizer and spray on the turpentine, perhaps letting the dissolved color drip and run down the paper in a few places.

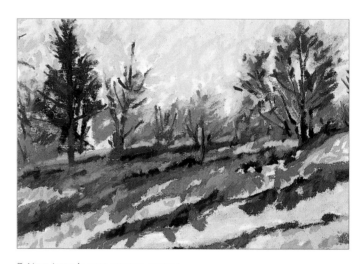

5 *Next I put in some warm greens . . .*

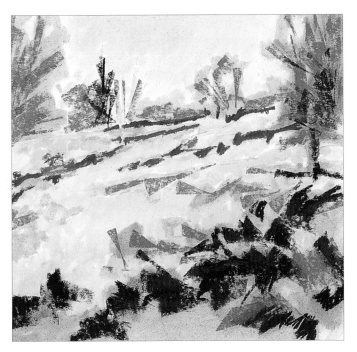

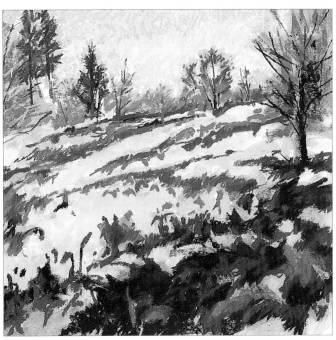

3 *After 5 minutes the wash was dry enough to continue. Working all over the paper, I applied some broad strokes of color with the sides of my pastels.*

4 *Using a combination of hard and soft pastels I added color and texture, beginning with dark colors that relate to the shaded parts of the design. While I was at it I hatched a few layers of pale violet and blue into the sky.*

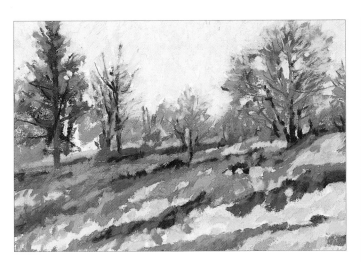

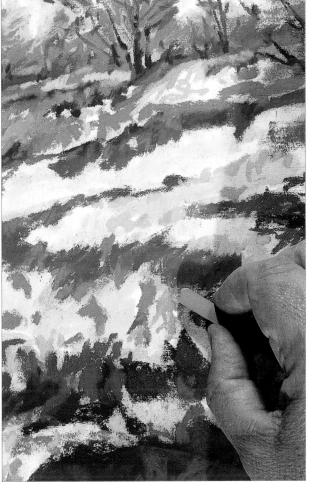

6 *. . . and a few muted yellows.*

→

7 *I added a few slashes of orange, using the tip of a hard pastel. Later, when I go over these marks with bright yellow, a little bit of the orange will remain visible, adding warmth and color vibrancy.*

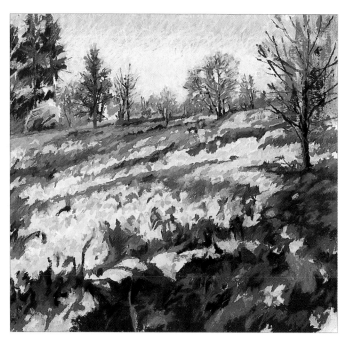

8 *At this stage I've begun refining the hillside trees while keeping the foreground active and abstract. I added the deepest darks to complete the low end of the value scheme. Now I'm set to add highlights.*

9 *But first I turn my attention to the trees on the ridge. Here I use a pastel pencil to slur the pigment around on the paper and to suppress some of the tree colors. Remember, it's all about "touch." Be sure to vary the pressure in order to get the most out of your pastels and pastel pencils.*

10 *I will turn a painting to any angle if it helps me function more effectively. There is no reason you need to keep the painting in one position as you work.*

11 Actual size detail
At last I get to the flowers. I wanted the final strokes to be bright, vibrant, and loosely applied so they would appear fresh and spontaneous.

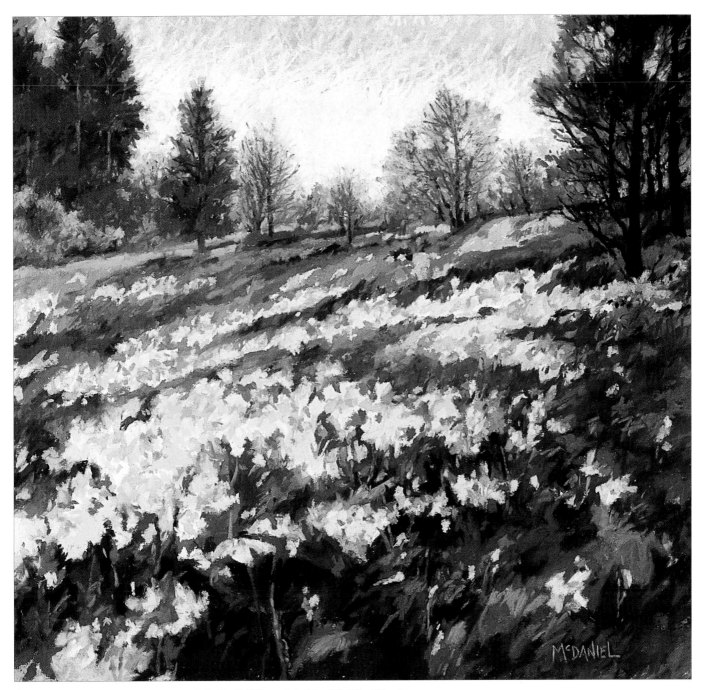

12 *Daffodil Hill*, pastel, 14 x 15" (36 x 38cm)

*My fascination with this scene began with my first glimpse of the
bright yellow foreground, yet my eyes always traveled up to the
trees on the horizon. To paint my impression I needed to decide
whether to render the flowers at my feet and merely suggest the
trees, or vice versa. I chose the latter for it more closely mimicked
my initial sensation. The foreground yellow is strong enough to
hold its place in the scene without an abundance of detail.*

*Ah, spring! That's the sensation I was after, with everything new
and full of promise, with the hillside adorned with a riot of vernal color.*

Examples the Turpentine Wash Technique

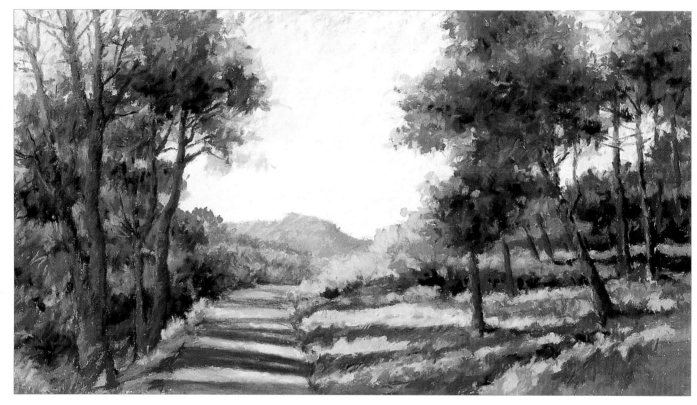

***The Road Taken**, pastel, 7 x 12" (18 x 30cm)*
With the help of a turpentine wash I was able to block out the composition quickly. I used extremely diluted oil paint on sanded pastel paper. The surface was dry in a few minutes, thanks to the sun and a gentle breeze. From there I proceeded with my normal pastel techniques.

"A variation you might want to try is to use an atomizer and spray on the turpentine, perhaps letting the dissolved color drip and run down the paper in a few places."

Pacific Northwest Passage, pastel, 8 x 11" (20 x 28cm)
Similarly, I saved a lot of time establishing the overall color of this scene with a wash before adding top strokes of pastel to model the form. Since I didn't have a level place to stand, I really appreciated the time saved by starting with a wash."

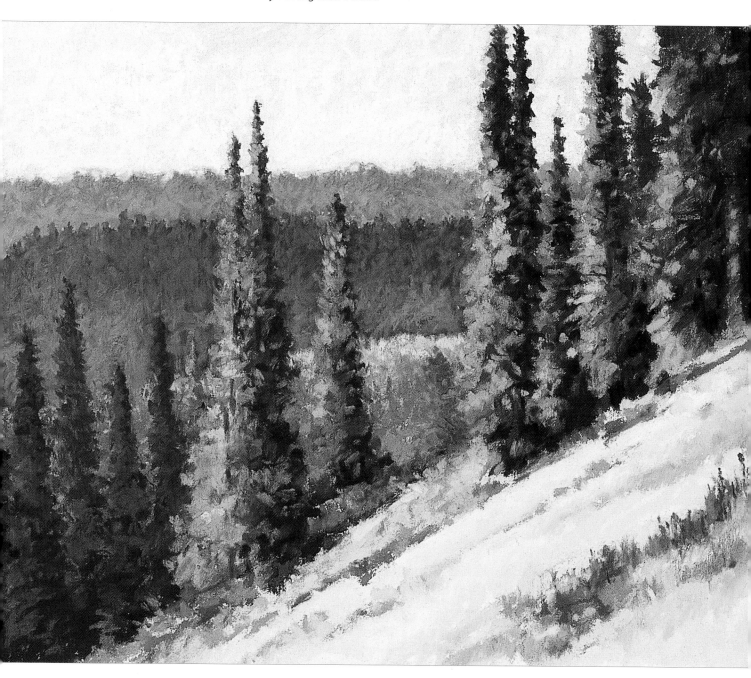

Art in the making **Underpainting with pure pigment**

Sometimes it's easy to isolate shapes in a scene and to block-in an underpainting with broad tones as shown in the previous demo. Another approach, however, is to paint pure pigment into specific tonal patterns to whatever degree of detail you find appropriate for the composition. This is very effective with a dense or complex image where you want to establish order in the initial stages of the painting.

Pure pigment, which is concentrated pigment dispersed in water, is ideal for this application since its color is intense, yet it doesn't fill in the tooth of the paper. There are no unpleasant fumes to contend with, the procedure is relatively simple, and clean-up is easy. You may choose a subtle color scheme or create a vibrant underpainting, and it's possible to apply the pigment in a series of transparent layers.

1 A thumbnail sketch helped me organize the composition and determine that a vertical format was well suited for evoking the height of the pines. I wasn't concerned with putting in detail, but focused on setting up the value pattern.

5 In order to avoid buckling the paper from water-based products, it is necessary to stretch it. The procedure is as follows. 1. Attach the paper to a vertical surface at all four corners, using a piece of tape on the back of the paper and another piece holding the tape to the board in front (see examples, Step A and B). 2. Underpaint or tone the paper with a water-based wash or mist all over (front or back) with water. 3. When the paper begins to sag slightly (one to three minutes), lift the tape at the corners and tug gently from the center of the paper toward each corner. Reattach the tape. Do this on all four corners, two at a time. The paper will not look flat until it dries.

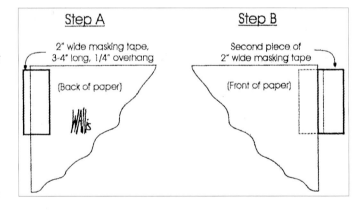

2 On a sheet of pastel paper that can withstand water-based media, I used a bristle brush to apply yellow pure pigment to the lightest areas and wherever I knew I was going to want a touch of sunlight.

3 While that was still wet, I added strokes of red in the mid-tone areas. In some places, the red and yellow mixed to create orange.

4 Adding a transparent layer of Ultramarine Blue pure pigment, I filled in the portions of open sky. By carrying the blue down over some of the yellows and reds, I also created a variety of greens in the foliage. I then stretched the paper flat and allowed it to dry before continuing.

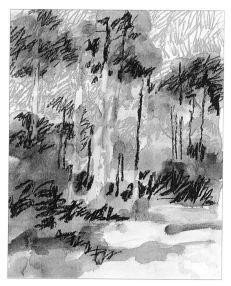

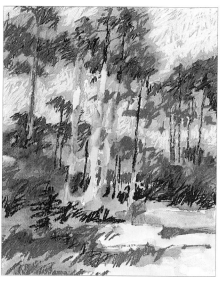

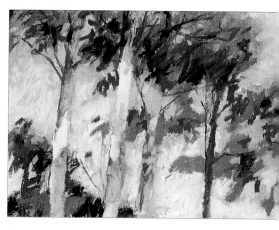

8 Still using loose, rough strokes of soft pastels, I added some dark spots and began to flesh out the high trees with a few branches.

6 Over the dry underpainting, I scribbled a light blue soft pastel into the sky and a deep green in areas of dark foliage. I did this casually, with little precision required at this time. In fact, the deliberate looseness added vitality and character as I applied subsequent layers over these first touches of color.

7 Next, I added another layer of blue to the sky, some mossy greens and a snappy tint of red-violet. Much of this color was covered up as the painting progressed, but the cool tones add variety and temperature contrast to the warm tree trunks wherever they peek through the top layers.

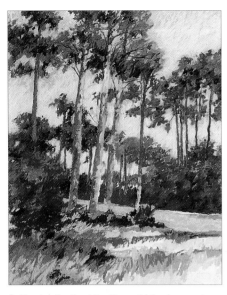

10 *Turning my attention to the low shrubbery and foreground grasses, I used the same process of adding scribbled strokes of color to develop forms and contours. By this time, I had covered most of the paper. I began to use hard pastels to hatch another layer of color over the softer strokes, slurring the pigments together. Slurring retains the crispness of the top strokes while unifying the colors beneath.*

9 *Gradually, the kinetic scribbles began to coalesce and the image became more clear. By working in loose layers I stay relaxed during the painting process and keep my options open to incorporate unexpected design possibilities.*

Actual size detail
For final touches I used very soft pastels and applied a few judicious flecks of intense color. I chose accent hues to harmonize with the color scheme and to provide sparkle to the painting. You can also see how the extra section of the path was added. Pastel is so opaque that it is relatively easy to make revisions of this sort.

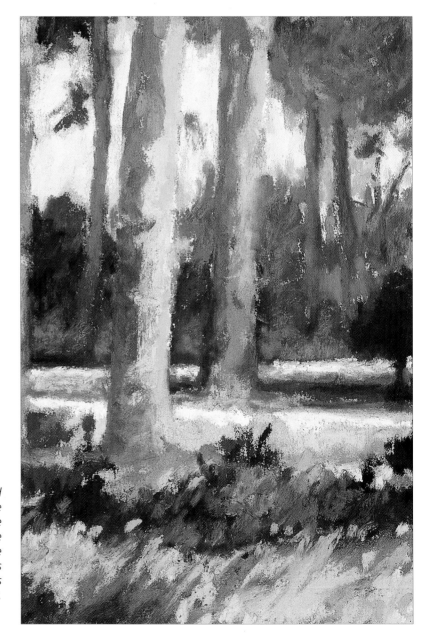

12 *Pinery Path*, pastel, 16 x 13" (41 x 33cm)
Since the initial composition was blocked out very quickly with the underpainting, I was able to move rapidly through the process of applying color. Although the design is always in my thoughts, the compositional underpainting allowed me to put most of my attention on the colors and the rhythm of the pastel strokes. Note too that while large areas of underpainting are not visible in this painting, its effect is still important. Bits of color from the underpainting show through between the surface strokes of pastel

Examples Underpainting with pure pigment

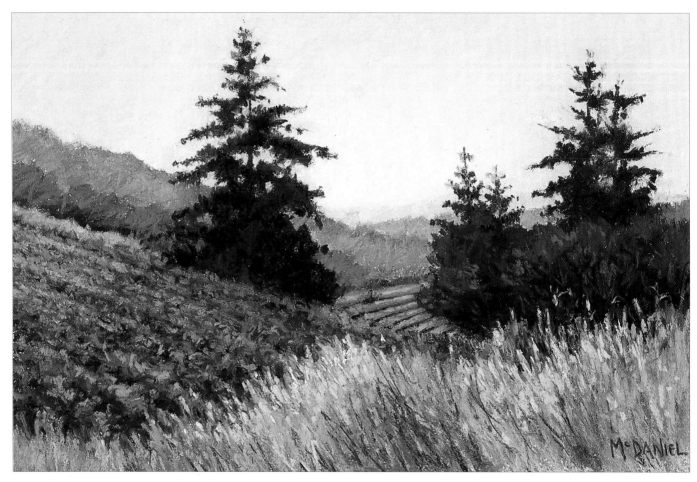

Upland Prospect, pastel, 7 x 11" (18 x 28cm)
I achieved the intense yellow green glow of the sky by starting with an underpainting of pure pigment. The depth of the dark areas was likewise prepared by an underpainting. In each case the preliminary wash prevented little specks of contrasting value from interfering with the top layer of pastel.

"Pure pigment, which is concentrated pigment dispersed in water, is ideal for this application since its color is intense, yet it doesn't fill in the tooth of the paper."

Hot Time, Summer in the Country, pastel, 12 x 15" (30 x 38cm)
*Normally the sky is the lightest portion of a scene, for it is the source
of illumination. Exceptions include snow, metallic reflections, and
white sunlit buildings. This cluster of farm structures provided me
with an opportunity to deepen the value of the sky without losing
the sense of light. I remember the slow afternoon pace, the
humming of insects, and stickers in my socks.*

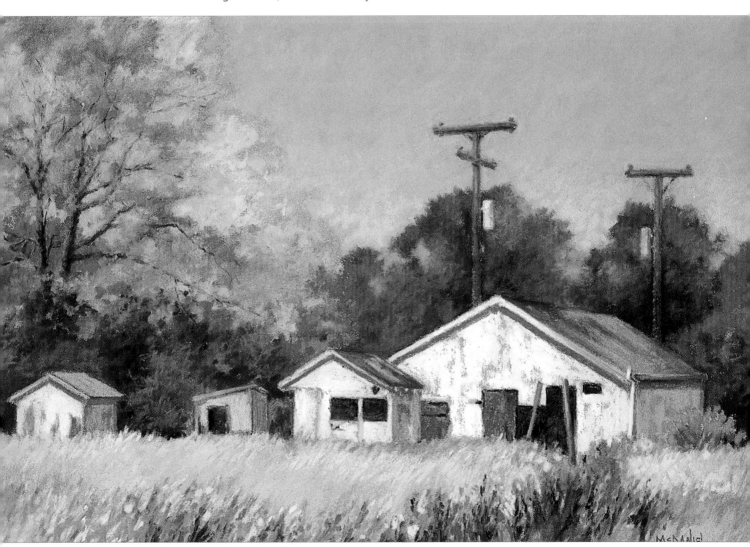

Art in the making The Intimate Landscape

Not all landscape paintings include deep space and spectacular vistas. Sometimes you may even choose to leave out the sky and look down at your feet. Here you may find a worthy still-life subject, and the opportunity to paint it out in the fresh air.

1 *I began with a rough compositional sketch, selecting a vertical format. What intrigued me was the dense mass of grasses to the right, and the way some "scouts" ventured out into the water.*

At work beside the water.

"I thought about painting the view across the water, it was such a beautifu

but as I set up my easel I was attracted to this scene right at the water's edg

few moments to make a little study of the bent stem
attracted my attention. By recording a few details I was able
to warm up to my subject, to become familiar with the way the
...ws, an... with the reflections in the water.

3 *Beginning with soft pastels, I blocked-in the major shapes with
a quick scribble stroke. The idea was just to get some pigment on
the paper. A broad stoke with the side of a pastel stick would have
worked just as well.*

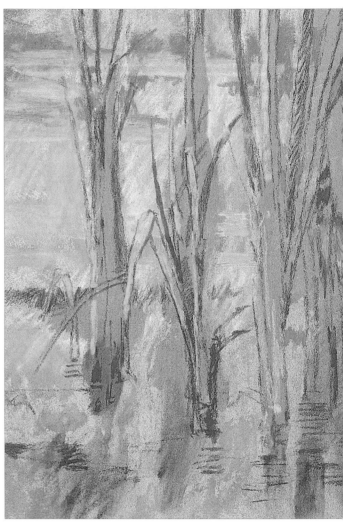

5 *Using hard pastels as soon as the wash was dry, I added a dull blue of medium value to establish the boundaries of the grasses.*

4 *Certain papers will be damaged with water, so a wash might seem out of the question. However, turpentine does not disturb the paper, so I used it here with a bristle brush to spread out the pastel into flat tones.*

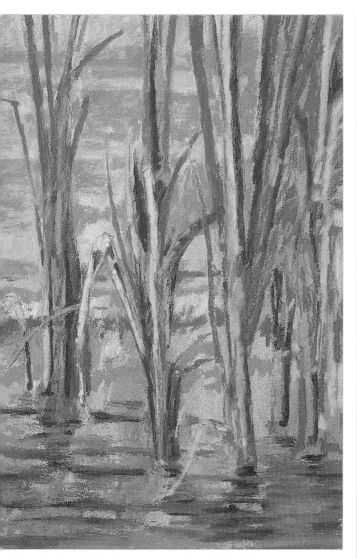

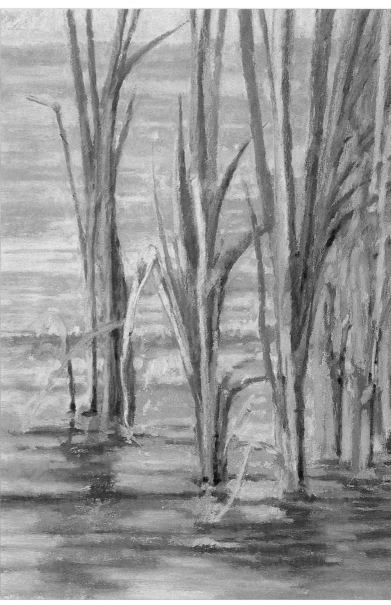

6 Continuing with both hard and soft pastel, I added some greens to the foliage and some blues and violets to the water. Since there is no sky visible, the water acts as the negative space between the grasses. It must have interest, yet remain subordinate to the plants.

7 Gradually I add more pigment to the water, using strokes that reinforce the horizontality of the lake. I sharpened the edges on some of the grasses and subtly indicated the distant shoreline at the top of the composition.

"Not all landscape paintings include deep space and spectacular vistas."

9 *Wade in the Water,*
pastel, 16 x 12" (41 x 30cm)

This pastel is a result of my frequent trips to Spring Lake, right in the heart of Santa Rosa. I thought about painting the view across the water, it was such a beautiful day, but as I set up my easel I was attracted to this scene right at the water's edge.

In the final version I have eliminated the distant shore. It didn't add anything to the composition except a stabilizing horizontal bar. It called too much attention to itself so I took it out. To complete the painting I added a few dark accents and some reflections and highlights in the foreground.

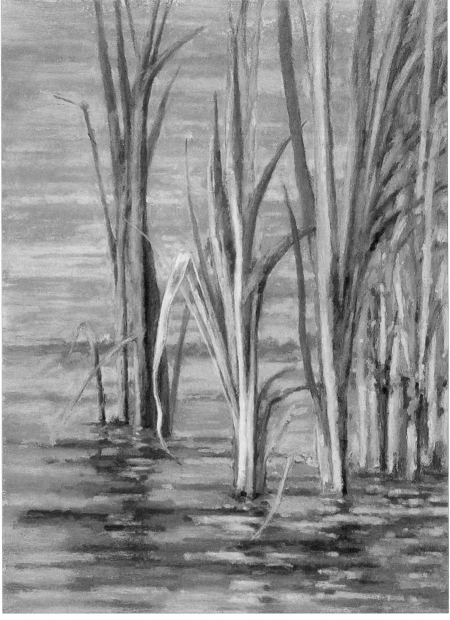

Actual size detail

Although the subject is "a bunch of grasses at the edge of the lake," the star grass, or focal point, is emphasized by contrast. It is bent where the others are straight, it is active and curvilinear where the others are straight and relatively passive, and it is the lightest light against the darkest dark.

Examples the Intimate Landscape

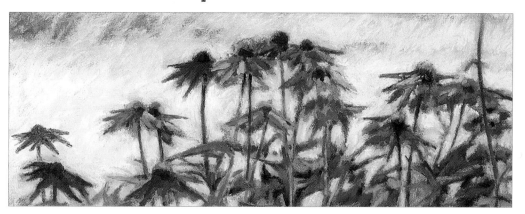

***Roadside Color*,**
pastel, 4 x 10" (10 x 25cm)
It's not nice to pick flowers from someone's yard but it's usually just fine to paint them. I saw these spots of purple while driving down a quiet suburban road. When I returned, I stopped and "picked" them harmlessly.

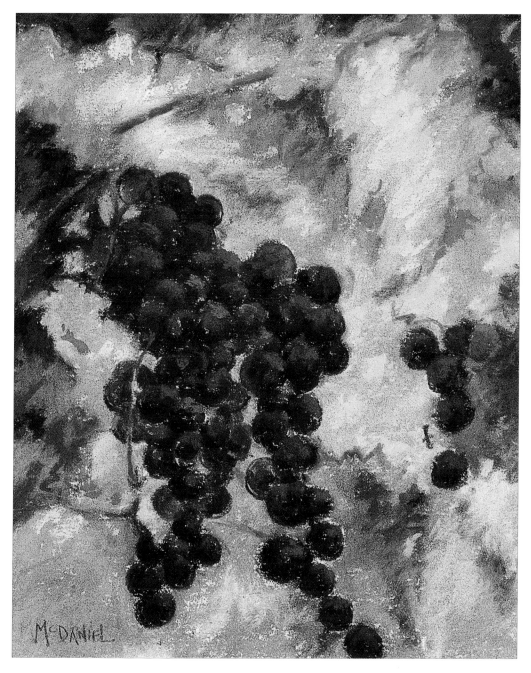

***Grape Group*,**
pastel, 9 x 6" (23 x 16cm)
Don't overlook the intimate view.

Tamalpais from the East, pastel, 11 x 15" (28 x 38cm)

When the sun begins to set, it can make the clouds dance. Here the solid mass of Mount Tamalpais is quietly resting on the far side of the bay, serving as an anchor to the lively sky and the active foreground rocks.

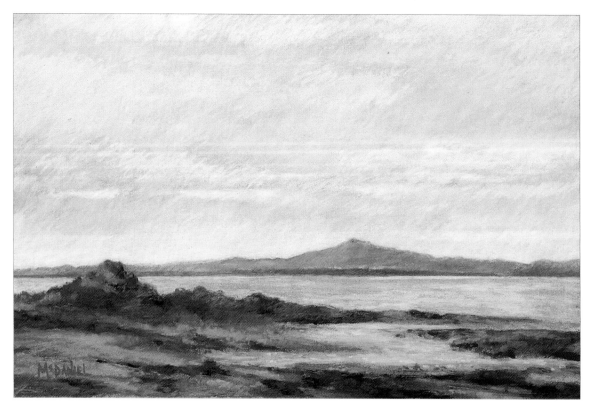

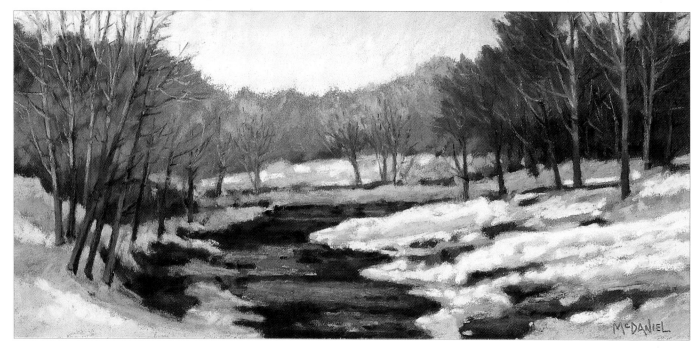

Frozen Flames, pastel, 6 x 12" (16 x 30cm)

The surprisingly intense color of winter light has lured plein air painters out into the cold for years. As long as safety and relative comfort are effectively addressed, a host of visual rewards awaits anyone who ventures outdoors to paint in the snow.

Red Poppies, pastel, 12 x 9" (30 x 23cm)

There is no deep space in a painting like Red Poppies. The contrast between figure and ground is substantially aided by sharp and soft edges and by advancing (warm) or receding (cool) color. Although there were additional flowers in the garden, I chose to subordinate all other floral activity to the dialogue between the poppy buds and blossoms.

To Recap:

- Simplify as you compose, squint as you examine the scene.

- If your composition includes deep space, don't paint details up to your shoe-tops. Take Corot's advice and refrain from painting anything closer than 20 meters.

- Look for contrasts and drama, seek the emotional connection with your motif as well as the aesthetic possibilities suggested by the view.

- Investigate your working site. Where will the sun be in an hour or two? Is the site level enough for your comfort? Is there room to safely back up from the easel?

- Plan the main thrust of the design in your sketchbook, do your thinking on paper, organize your thoughts and become familiar with the motif through your sketch.

- Avoid 50-50. Consider the interplay between dominant and subordinate elements.

- Set up your materials quickly so that everything you need is at hand.

- Use the same proportions in your painting as you established in the sketch.

- As you begin to draw the scene, start by "tagging" the placement of the prominent points in order to keep your proportions in check. Refer to both your sketch and the actual scene as you block-in the composition for the painting.

- Paint relationships and intervals, not a collection of objects.

- Take brief breaks while you work to reduce fatigue.

- Stand back to evaluate your painting.

- Finish with a bang, not a whimper. Don't fuss over it.

Back In The Studio

Sometimes the objectivity of working in the studio helps to sort out the truly important features in a composition.

Every plein air painter I know has a studio. Some are simple rooms for framing and storage, but most others are substantial workspaces. If you have traveled to Giverny or read books on Monet, you may have admired his magnificent studio of nearly 3,000 square feet. And it was not his only studio on the property — it

"But we're home, Toto . . . we're home!"

— Dorothy (from the film *The Wizard of Oz*)

was one of three. Of course the immense gardens served as his own private outdoor studio, and that too is worth noting.

Cezanne's studio was much more modest, at 600 square feet. Nonetheless it provided storage, workspace, and a refuge from the elements. I find that my own studio is welcoming and comforting. I may go out to paint, but I always come "home."

A studio is an artist's "nest" or "comfort zone." It is a sheltered environment in which one can work out ideas, evaluate paintings done in the field, and prepare artwork for exhibition. The studio is also necessary for times when painting out of doors is impractical, such as when creating a large commissioned piece.

As I stated earlier, most pastelists have worked, or continue to work, in other media. Likewise, the majority of outdoor painters have spent a considerable amount of time in the studio, and still have a demonstrated need for maintaining an indoor workspace.

A different space (indoor versus outdoor) prompts a different attitude. Your adrenaline flows when you paint on location, and the resulting paintings are charged with energy. The excitement you feel when working in the field, however, can mask subtleties of composition that might be more apparent in the constant light of the studio. There are fewer distractions indoors, and you see more clearly. In the studio, you evaluate the painting on its own merit, without direct comparison to the motif.

We should be concerned primarily with making good art. A painting must effectively express a coherent idea, regardless of its subject or its method of creation. Sometimes the objectivity of working in the studio helps to sort out the truly important features in a composition. This allows you to evaluate the painting on purely artistic terms, and carry out adjustments to make it a stronger piece. The emotional truth of a painting is far more significant than a literal transcription of facts.

Adjuncts to Painting on Location
Working on the spot, directly in front

Spring Hope Springs Eternal, pastel on sanded paper, 33 x 54" (84 x 137cm)
I only work up to a modest size when I'm out in the field. For larger paintings I prefer to work on my studio deck, sheltered from the wind, and close to any extra materials or equipment I might need. Spring arrives much earlier in California than in New England, and the "golden hills" become a lively, saturated, cheerful green. I encounter this view of Taylor Mountain periodically throughout the year, and always enjoy its chameleon-like changes.

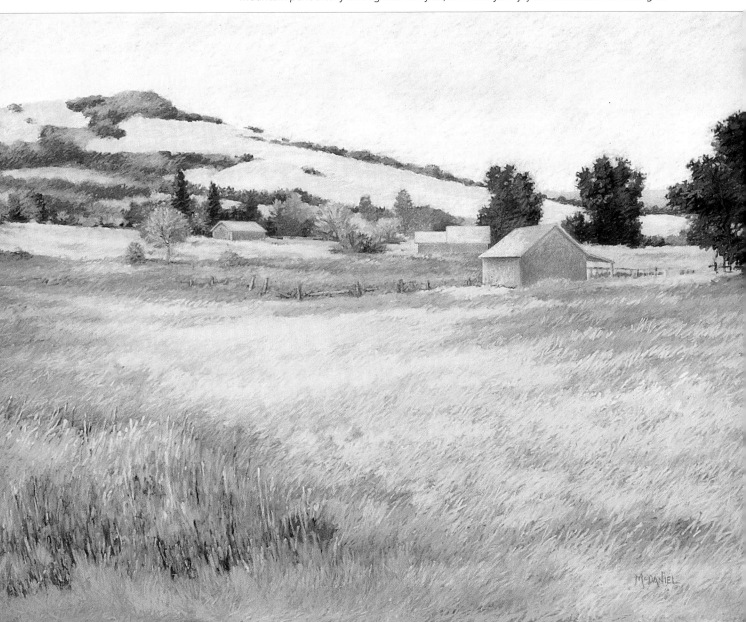

Russian River Vineyard,
pencil, 11 x 18" (28 x 46cm)
*One of the standard
approaches to landscape
painting: I made the drawing
on location . . .*

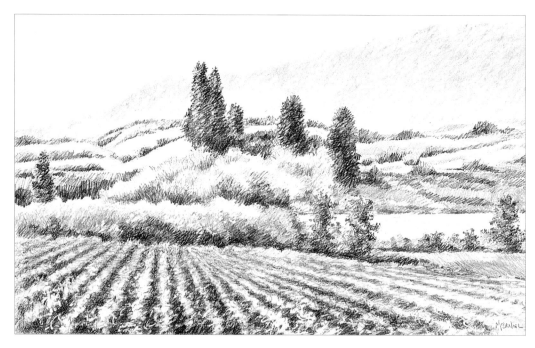

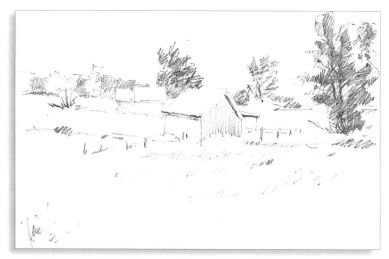

Pencil sketch.

Pencil sketch.

of the motif, is absolutely wonderful. It is a challenge, and it is a joy. But there are also a number of ways to expand this experience once you return home. Many painters complete some of their work *en plein air*, but leave final decisions for the studio. After a few days or a few weeks have passed, they study the painting with a fresh perspective. Having forgotten the unimportant elements of the scene, they are free to concentrate on their remembered impression, and to combine their emotional response with pragmatic design choices.

Sometimes I don't finish a painting on location. Most of these I bring home and store in racks. Periodically I take them out and examine them, and if the spirit moves me I start up work again. Whether I call on my imagination, use sketches and studies, or look out my window, I can usually complete the painting without a return trip into the field. In fact, sometimes it's better that I'm not in front of the real scene so that I can paint the imagined scene instead. It helps to remember the sentiment of Albert Einstein, who said, "I am enough of an artist to draw freely upon my imagination. Imagination is more important than knowledge. Knowledge is limited. Imagination encircles the world."

I also like to work first from direct observation, then respond to my initial

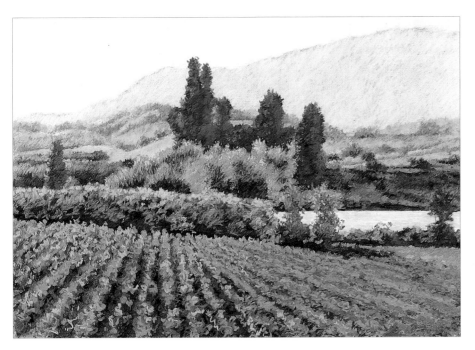

Russian River Vineyard,
pastel, 13 x 21" (33 x 53cm)
. . . then I created the painting in the studio. I recorded a few color notes when I made the original drawing so I had a plan to follow for the painting.

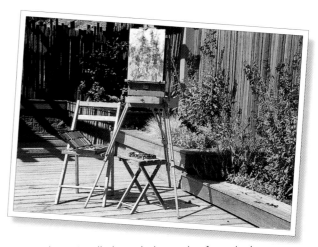

Every day as I walk through the garden from the house to the studio (yes, it's a great commute) I pass by these cheerful penstemon blossoms. It is so easy to drag an easel out onto the deck. Plein air doesn't always require extensive travel.

Garden Color, pastel on Pastelbord, 16 x 12" (41 x 30cm)
With such a densely packed cluster of flowers I needed a quiet background, yet I didn't want it to be flat. I underpainted the background with several of the dark colors that are visible in the foreground, then added pale greens and yellows on top, weaving the colors together to form a light-colored backdrop with hints of the foreground color.

Wine Country, 39 x 54" (102 x 142cm)
Like Russian River Vineyard on the previous page, I created this painting in the studio based upon drawings and color notations made at the site. The studio is much more convenient for painting large works such as this.

Woodstock studio in summer.

Woodstock studio in winter.

impression. As I do so, I further reduce the concept to its essence, either by eliminating the non-essential or by amplifying elements for the sake of greater impact. At times I will collect several plein air studies from a particular site, spread them around in my studio, and then paint a new composition, often much larger, that is a combination of all the others. In essence I am inventing a scene that doesn't exist by responding to several scenes that do.

Open Air Studio

I like to work on my studio deck. It's not completely *out on location*, nor is it completely *in the studio*. It has elements of both. It's similar to the difference between riding in a sedan or in a convertible with the top down. They are both automobiles and perform basically the same function of transportation, but there is a clear difference.

My studio deck has nearly all the comforts of the studio. There's no need to pack or transport equipment and supplies; lunch is readily available; and I have music if I choose — yet I still get the fresh air and satisfying feeling of working *au naturel*. In addition, I am free from the nuisance of paint fumes and pastel dust. When I'm not out in the field, I work on my studio deck as often as possible. I keep an old aluminum easel out there year 'round.

Even though I might be working from sketches, as if I were in the studio, I like to take the work out onto the deck behind the studio. Working in the open air I find it easy to keep the looseness and the sensation of light that I would have obtained had I actually been working on location. It is ironic that I have a large well-equipped studio, but spend so much time either on location or painting on the deck and in the garden. Nonetheless I love my studio and find it indispensable.

Monet made great use of his garden as an open-air studio, and I highly recommend painting in your own garden if you have one available to use. The safety of the nearby studio is a comfort, and the mechanics of transporting equipment are greatly

The storage racks in my Woodstock studio.

***Niagara*, pastel on sanded paper, 14 x 21" (36 x 53cm)**

This painting stayed in my racks for a few years. I didn't like the dark triangular shape in the bottom left corner, but that is how the scene appeared from where I was standing. I wished I could fly around the corner to get a better view of the falls. Nothing I did to adjust the corner helped enough to suit me, yet I couldn't throw the painting away for there were other parts that I liked.

***Niagara*, pastel on sanded paper, 14 x 21" (36 x 53cm)**

After a decade I pulled the painting out of the racks once more and decided to pretend I could fly to the vantage point I would have preferred. The image is simplified and the power of the falls is increased considerably.

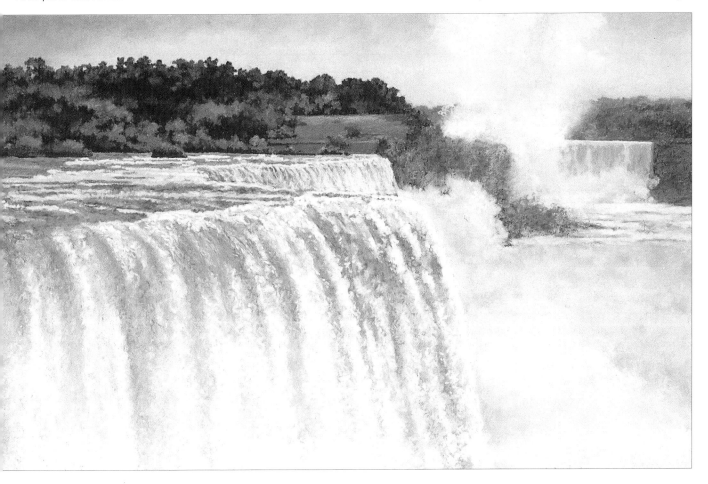

Spider Rock, *pastel, 8 x 6" (20 x 16cm)*
Canyon de Chelly, in Northeast Arizona, is renowned for its strong colors and dramatic shapes, and is a popular painting destination for artists. According to legend, this 426-foot high sandstone pinnacle was the home of Spider Woman, who taught the Navajo how to weave.

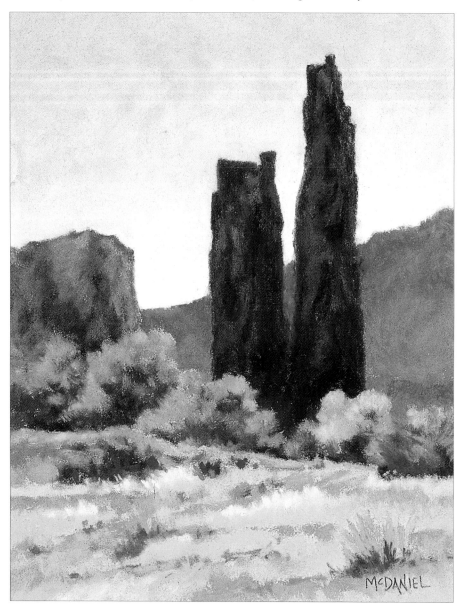

and just seething with an aura of wilderness. I talked to her briefly and was amazed when I saw her stack of photo reference. She did all her work in the studio, but it was as loose as could be, and it revealed a true sense of light. She said she used to work in the field extensively, but had to stop after a serious car accident. During her extended recovery from several surgeries, she began working from photos. Her work was definitely in the Plein Air Style although created in the studio. She said her previous outdoor painting experience was crucial to her development and she still is fascinated by the surprises of nature. Although her painting trips are infrequent because she can't walk far, she sometimes works from her car, and feels fortunate to still be "in tune" with nature when she works in the studio.

There are so many ways to approach painting the landscape and it is not my intent to judge. Working on location is beneficial to an artist whether he or she chooses to work exclusively *en plein air*, partially in the field with finishing touches applied in the studio, or entirely indoors from drawings or studies made in the field. The knowledge gained by working directly from nature will improve the work of every artist.

A studio set-up will vary according to your needs and the space available. The following suggestions may be of use when planning and outfitting your next studio. Aside from its use as a workspace for making art, a studio's functions are usually dedicated to framing, repair, and storage. For some it may also include an office while for others it is an oasis devoid of telephone and computer.

Lighting
The vast majority of literature pertaining to painting has referred to artists of the Northern Hemisphere. Consequently the term "North light" has become closely linked with painters' studios. Such light is prized because it does not emit direct rays of sunlight into the building's interior. It is reflected light and therefore remains constant even as the sun moves through the heavens.

reduced. It is a fine place to study the effects of outdoor light. Painting in your garden is similar to camping in your back yard, where you still get to sleep under the stars, but you don't have to travel far, and you needn't fear any coyotes.

In the Plein Air Style
Once I was visiting an artist friend of mine and saw for the first time the work of another artist in the same building. The landscapes were fresh and animated. The work was vibrant

Skylights on a north-slanting roof or a bank of windows on the north side of a room offer steady illumination throughout the day. While direct light from windows facing the other points of the compass may be enchanting, you might be annoyed working in a room with a bright trapezoidal patch creeping across the floor.

A Point to Consider

Completed artwork will be viewed most often under artificial light once it has been sold. It's a good idea to view your work under similar lighting conditions before showing it in public. Incandescent lamps are the most common, though halogen lamps are becoming more widespread. Practically any painting that looks good under incandescent lights will look even better under halogen lamps.

Full-spectrum and color-corrected fluorescent lamps exist, but I don't use them. Full-spectrum lights simulate north light, and I understand they are quite pleasant for those without natural light. I've never liked fluorescent lighting, however. In its worst form the light flickers and the color is grotesque. Although there have been improvements to fluorescent technology, I still shy away from them.

Night Work

The system I find most effective for working at night is to aim lamps at the ceiling and let the light bounce back into the room. Glare and hot spots are eliminated and you feel like you're working in a cloud of soft light. Normal clamp-on lamps, available at most hardware stores, work wonderfully. If the ceiling is too high, or if it is an odd color, suspend a white cloth to create a false ceiling. Make certain you maintain adequate room above the lamps for safety.

Add task lights as you need them, but refrain from attaching a lamp directly above your easel. If your painting is lit too well, you run the risk of getting bogged down in excess detail.

Storage

I have several sizes of racks for both completed and unfinished work. I like

***Early Morning**, pastel on sanded paper, 12 x 26" (30 x 66cm)*
Though the composition is based on the existing vineyard, it seemed weak to me, without a visual path to enter the painting. The sea of grapes did not seem inviting.

***Early Morning Path**, pastel on sanded paper, 12 x 26" (30 x 66cm)*
I decided to introduce an actual path and to provide some more interest in the scene. While I have strayed from reality, I have improved the design and created a more inviting space. I also changed the painting's title slightly.

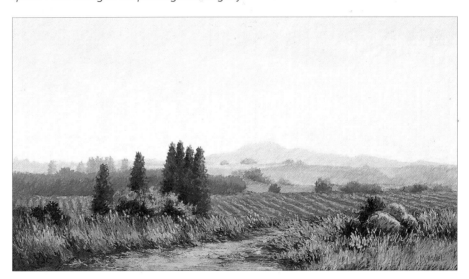

the simplicity of racks that run from floor to ceiling and are divided into various sized bins, rather than individual slots for paintings. I separate the paintings with cardboard so the frames don't rub against one another.

Flat files or map cases are tremendous for storing paper supplies and unframed work. Rigid cardboard or wooden boxes turned on their side create a serviceable house to store small works. I make dividers of cardboard that I tape vertically inside the box. Since I paint most of my

***Saratoga: Spring**, pastel, 16 x 13" (41 x 33cm)*
*The scene was filled with potential compositions. For a moment I couldn't decide which way to go.
I had a hankering to do a vertical composition so I selected this view. As I was working my mind
kept wandering to the use of a horizontal format so that the branches could really spread out.*

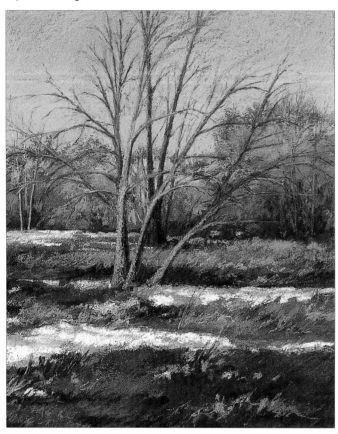

***Sketch**, pencil, 7 x 11" (18 x 28cm)*
*Before leaving for the day I jotted down these ideas with the
thought of painting a horizontal image sometime in the future.
It was March and the snow was melting rapidly so I knew the
scene would change before I could return. Although I liked the
original pastel version, I wanted to explore the theme in a
horizontal shape once I was back home.*

pastels on paper that has been taped to foam board, I can rest a painting or two inside each slot at a slight angle. The rigidity of the foam board holds the paintings in place as long as I don't shake the box.

Another safe system for the storage of pastel paintings is known as *passe partout*. This entails covering the painting with mat and glass, but no frame. The glass is usually held in place with a strip of tape along its edge. The painting is now completely protected, and several can be stored side-by-side without damage.

Another storage variation involves pairing two paintings of equal size, each mounted on foam board or other rigid support, and placing them face-to-face. Obviously they need to be separated, but this is easily accomplished by taping a strip of foam board along the margin between the paintings. Tape them together so they cannot move and they are protected.

Label the paintings on the outside so you'll know what they are.

"Hospital"
In an alcove near my easel I have established my infirmary, where I store damaged work that awaits repair. I also send work here when it can use reworking, simply because I'm unhappy with it.

Admittedly there are times when a painting is completed, framed and perhaps exhibited, and then sometime later I look at it and the painting just doesn't seem as good as it could be.

Does it have a weakness in the design? Was I too emotionally involved with the content of the piece to view its form? Was I too involved with its form to pay enough attention to the content? Or have I grown as an artist, and now understand what I didn't know then. Into the hospital it goes. When the time is right, I'll perform surgery.

Mirrors
A well-equipped studio will frequently include a mirror on the wall opposite the easel. Shapes are reversed when seen in the mirror, yet the image is still intelligible. What was once familiar is now new. If you have become accustomed to your mistakes, they may now stand out clearly in reverse.

Ventilation
Airborne particles of pastel dust are the primary health concern for pastelists. Many of those who work in the studio recommend wearing special dust masks or the use of air purifiers. If you use an air filtration device, such as one with a HEPA filter (High-Efficiency Particulate Air), place it so that you and the filter are on opposite sides of your workstation. In other words, you don't want the dust to pass by you on its way to the filter.

My studio is divided into several task areas. There are tables to repair or

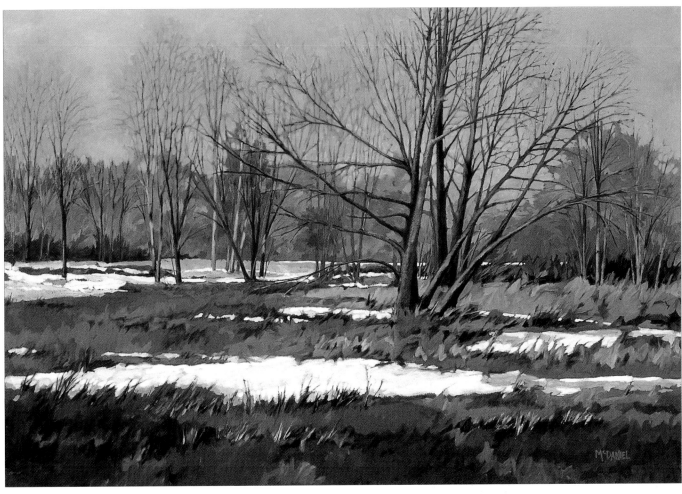

Saratoga: Spring, oil, 30 x 44" (76 x 112cm)
Using a combination of the sketch for composition and the pastel for color,
I developed this painting in the warmth of my studio.

assemble frames, shelves and cabinets for supplies, and racks for storing paintings. I have separate areas to work on drawing, pastels, or oils. I also have a "clean room" where I store framed work. This is one part of my studio that remains reasonably presentable. The rest can get, well, let's just say the rest can appear at peace with the concept of chaos.

Some Final Thoughts

Perhaps the greatest function of a studio (other than storage) is its nurturing environment. A studio becomes a sanctuary where the artist succeeds and fails, experiments and struggles, and keeps working through it all. It is a laboratory where ideas are grown, and where their evaluation takes place.

A painting benefits from a serious

examination of its merit, but an artist must avoid confusing personal likes and dislikes with subjective analysis. It is entirely possible to like a painting that is not particularly good, and just as possible to dislike a good painting. Your individual likes or dislikes may reveal attributes of your own personality but they don't speak to the intrinsic quality of the artwork.

As artists we must retain our passion for painting, yet we shouldn't neglect the process of making better art, even when the decisions we must make are difficult. We become so involved with our own work that it's hard to remain objective. Our time and our heart have gone into the painting. Moreover, we've become familiar with the idiosyncrasies of each piece, whether or not they are correct.

In order to achieve objectivity, artists

have employed a number of devices over the years. Try looking at the image reversed in a mirror. Place the painting in a dimly lit corner of the room and see if the shapes make sense now that the detail is less visible. Put the painting in a rack for a few months, then pull it out to see it anew. The aim is to see the work with fresh eyes, as if for the first time, with the eyes of the viewer in mind.

The studio is a natural place to critique artwork, and accessories such as mirrors and lights are readily available. But there are several procedures that work in the field as well as in the studio.

Squinting is a basic technique, yet one of the most effective methods for eliminating detail. Extraneous embellishment disappears, values become more apparent, and you see in an instant if your design is strong.

Stand back from the painting. The simple act of stepping away from the

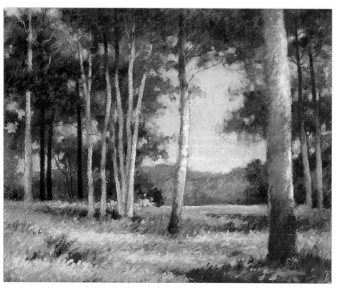

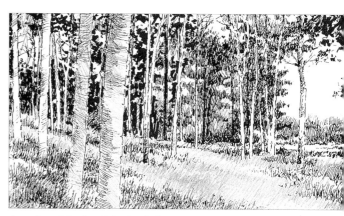

Promise of Spring, ink, 4 x 8" (10 x 20cm)
There were so many trees in my view I chose a horizontal format to show the vastness of the scene. I like this composition and would enjoy developing it into a painting someday.

Promise of Spring, pastel, 11 x 12" (28 x 30cm)
I've always been attracted to glades in the woods, settings that seem just right for a picnic. Here the repeated verticals of the tree trunks captured my interest. While working on the pastel, I began to envision the scene in different formats, accentuating the rhythm of the trees.

easel will help you tremendously in your ability to see the effectiveness of the composition.

Stand *way* back. Move back so far that the painting becomes the size of a postage stamp. Look at the design although you can't decipher the content of the painting. Move a few paces closer and stop. Look again. Continue this process of advancing, stopping, and looking. By the time you're close enough to get back to work, you'll have plenty of opinions on what needs to be done. If everything seems to be working well, take a break — you deserve it.

Turn the work upside down or on its side. It won't make a whole lot of sense, but the abstract design will still be visible even if the narrative is wacky.
View the painting at an oblique angle. You can hold the work out at arms' length and look across its surface, or if the painting is on an easel, step to the side at about 30 degrees or so. Proportions will be all skewed, but the image will remain intelligible. Flaws are often accentuated under these conditions.

If you stare at a point just to the side of your painting, and not directly at the

image, your peripheral vision will eliminate details and simplify the composition.

When examining a painting, don't lose the concept of the whole by concentrating too much on the particular. It is natural to focus on isolated components for a critique as you run through a mental checklist (Is there good balance of form, of values, of intervals, edges, and emphasis?). But all strategies must work together, not independently. There is danger in separating the various elements of composition if you fail to consider them collectively. A successful painting integrates all the components of design with the total conceptual vision of the artist.

As you critique your artwork, don't confuse *clarity* with "absolute fidelity to the real scene." Remember that painting is for the most part a two-dimensional representation of a three-dimensional world. Abstract concepts and laws of perception must be adroitly employed to maximize visual communication. You may find it necessary to simplify, distort, or amplify aspects of the scene in order to make your concepts clear. As Picasso so astutely said, "Painting is a lie that tells the truth."

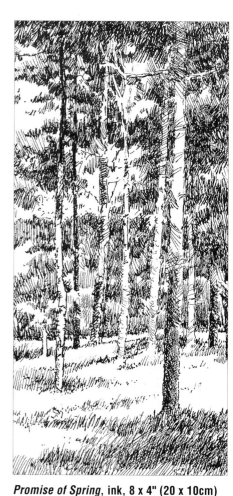

Promise of Spring, ink, 8 x 4" (20 x 10cm)
Although I liked the previous drawing, it did not convey the great height of the trees. Intrigued by the two-to-one format of the other drawing, I decided to rotate my composition by 90 degrees with the hope of accentuating the verticality of the woods.

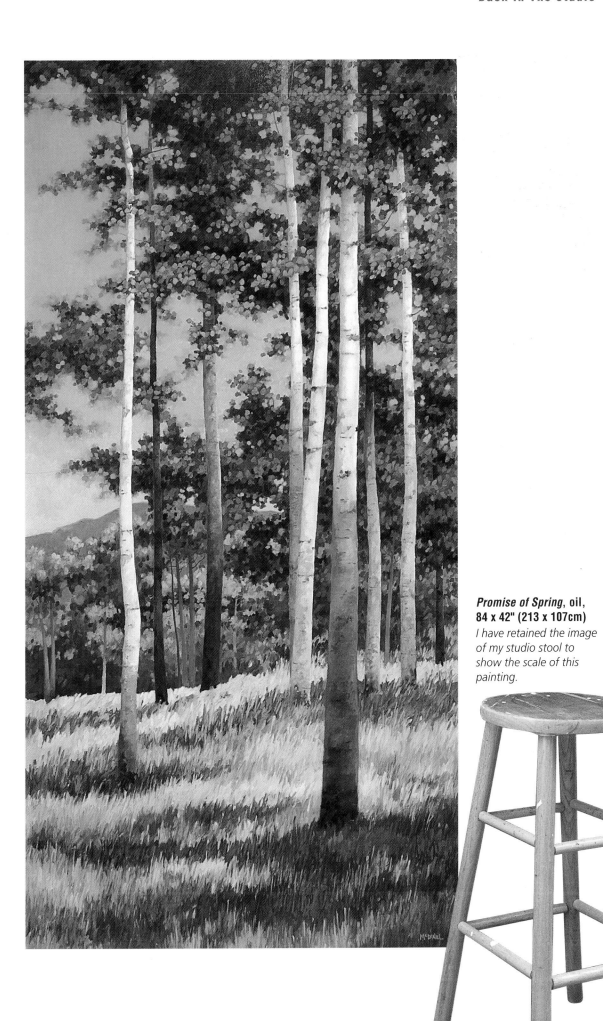

Promise of Spring, oil,
84 x 42" (213 x 107cm)
*I have retained the image
of my studio stool to
show the scale of this
painting.*

Art in the making **Pastel over watercolor**

Diamond Head, pastel, 6 x 9" (15 x 23cm)

Many artists, including Edgar Degas and Mary Cassatt, have used pastel over watercolor. Pastel can be applied on top of a preliminary watercolor wash, but can also be used to correct or invigorate a dull, overworked watercolor painting. Since pastel is so opaque, you can even obliterate the watercolor image completely (paint a bowl of fruit on top of a portrait of your dog, and vice versa).

While some may do a watercolor sketch on location and then start a new painting in the studio, a pastelist can work right on top of the original sketch. Most watercolor paper has sufficient tooth for you to add some pastel. A layer of workable fixative on top of the watercolor will also help.

This familiar landmark located in Waikiki, on the island of Oahu, is known as Kaimana Hila, which means "Diamond Hills." Its geologic history is interesting. Strong trade winds blew volcanic ash towards the southwest part of the crater after the eruption. That is the reason why one side is taller than the other, giving Diamond Head its characteristic shape.

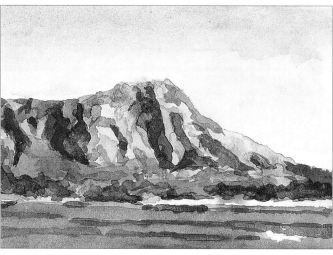

1 *The original watercolor painting captures the celebrated profile of Diamond Head, but the colors are weak and I'd like to extend the sweep of the mountain on the right side of the painting. I don't plan to radically change the composition, just strengthen it.*

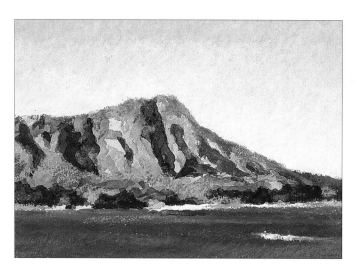

4 *I cleaned up the ragged contour of the mountain with pastel pencils and worked on the water, making it smoother and deeper in tone.*

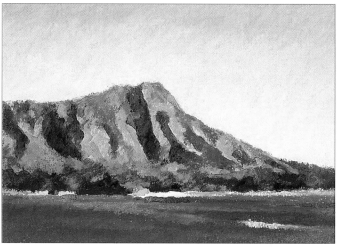

5 *With a few finishing touches I thought I was done. A month later I decided to add more color.*

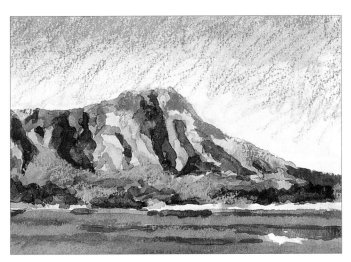

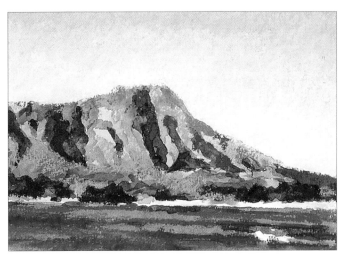

2 I began by spraying a layer of workable fixative over the watercolor. Next I used hard pastels with a hatching stroke to apply a layer of energetic color. I also extended the image on the right side.

3 I smoothed out the sky in order to make a seamless transition to the extended portion of the design. Then I added a few touches to the water.

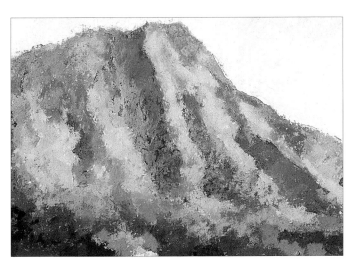

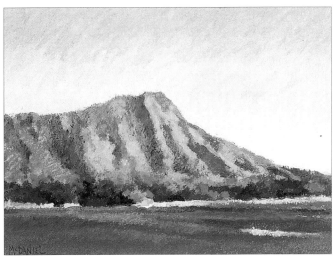

6 Actual Size Detail
Here you can see the result of my adding more layers of pastel. The color is richer and the mountain seems more substantial.

7 The initial watercolor served well as a springboard to get started, but I am much happier with the stronger color and texture of what is now a pastel painting.

Art in the making Studio response to location work

Stonehenge, pastel, 10 x 24" (25 x 61cm)

This is a studio painting. It illustrates one of the positive aspects of frequently working on location, and that is the ability to generate a convincing studio painting based on drawings and small color studies. My advantage here was a lot of source material. I had a basic ink drawing of a composition I wanted to explore, two drawings with more detail, and a small painting from a different angle.

Stonehenge has a long and mysterious history, and

I wanted to conjure up a bit of its mystique in my studio before I began painting. I have some pebbles from an area nearby Stonehenge. They were not taken from the actual site, but I am convinced that these few pebbles are descendants of little crumbs that fell off the large Sarsen stones as they were transported across the Salisbury Plain thousands of years ago. I arranged my little pebblehenge near my easel, set out my drawings, and began painting.

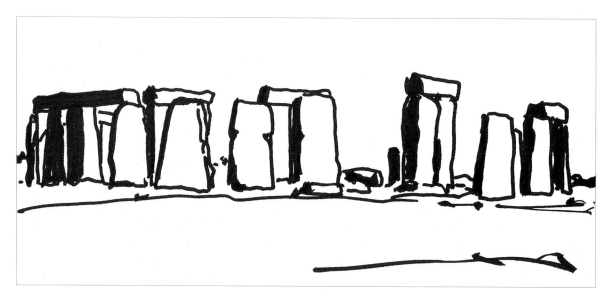

1 _The stark simplicity of this ink sketch is lacking in texture and detail, but I find the composition promising. The intervals set up an intriguing rhythm._

"These old weathered stones have a complex texture and I chose to suggest their surface character by applying multiple layers of pigment."

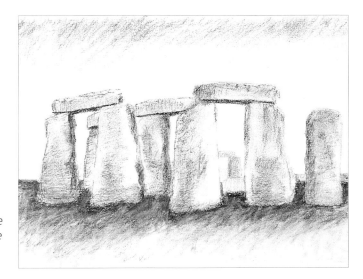

2 *This drawing provides me with information about the texture and the mass of these gigantic stones.*

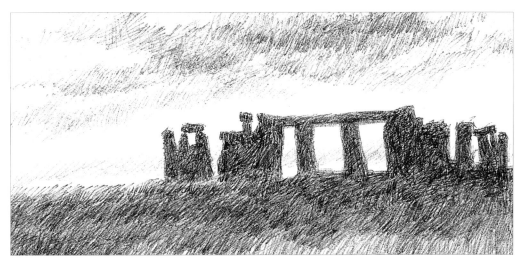

3 *I didn't use much from this drawing directly, yet I've always liked its sense of mystery so it stayed pinned up on the wall next to my easel. I found myself looking at it frequently, even if it wasn't specific source material for the composition.*

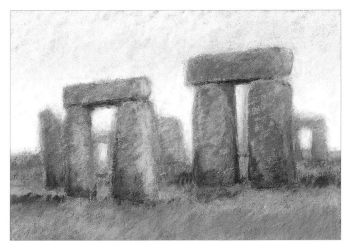

4 *This small pastel sketch proved indispensable as I worked. It reminded me of how I felt about the light falling on the monumental forms.*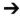

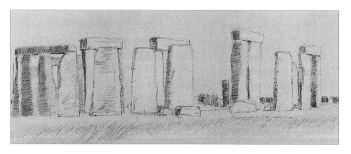

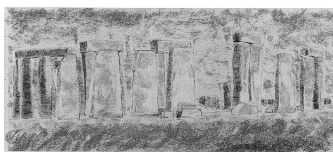

5 I began on gray paper with a charcoal sketch based on the ink drawing. I concentrated on maintaining the proportions and spacing of the original sketch.

6 With broad strokes of half-stick pastels I was able to fill in the basic shapes quickly.

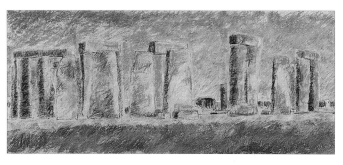

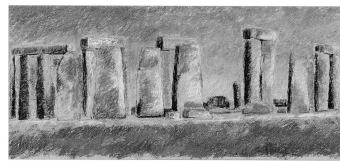

7 Upon this foundation I began to add layers, using a combination of hard and soft pastels.

8 Next, I reinforced the value pattern by adding more darks . . .

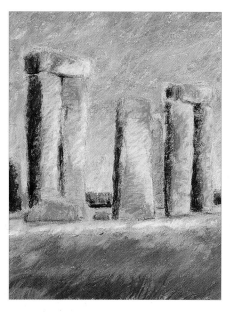

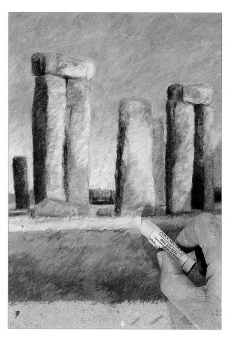

9 . . . and then adding some surface color. These old weathered stones have a complex texture and I chose to suggest their surface character by applying multiple layers of pigment.

10 Once the image was well under way I added finishing strokes with soft pastel.

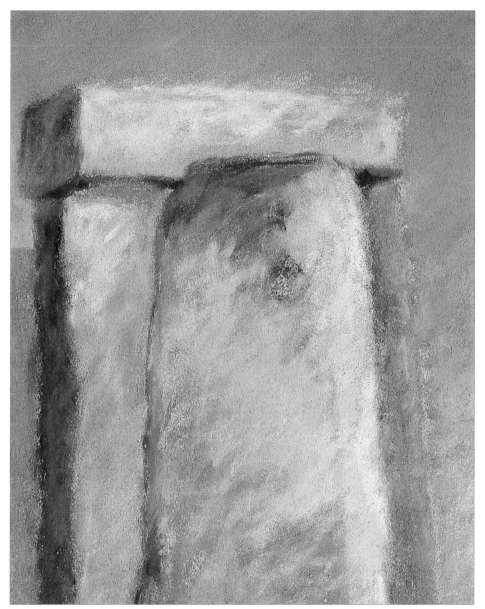

Actual size detail
You can almost feel the granularity of the stones because of the way the pastel pigment adheres to the paper.

No wonder this has been such a popular motif. It is a striking blend of a man-made structure with its human and historical significance as well as the organic, crumbling shapes of pure landscape. There is a wonderful interval between the stones that changes with every step you take.

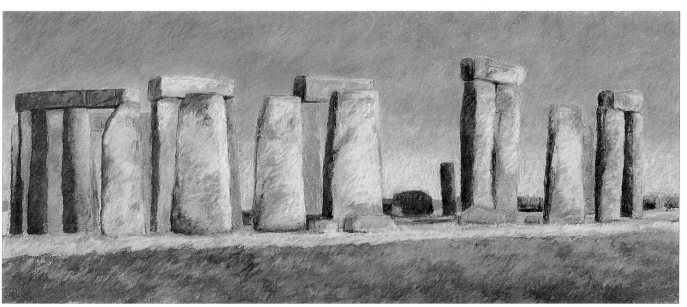

Afterword

"I want to paint the way a bird sings."

— Claude Monet

When I head out to paint on location, I'm never certain what I'll find. I suppose that's one reason why I go. It's the surprise. No matter what I expect, I always find something new.

Nature is so large, so powerful, so infinite. I find that merely taking a walk outdoors is like a tonic, restoring my spirits and balancing my outlook on life. When I draw or paint in the open air, the admixture of an art activity with the centering influence of nature can be magnificent.

The thrill of meeting a challenging situation head-on is another factor of interest for me. Painting on location is not always easy, the game is certainly re-complicated once you venture outside, but it is the relative difficulty that attracts many of us, for artists love a challenge. The light changes, the wind blows, the bugs bug, but still we come back for more.

Some days everything is glorious. The work progresses so effortlessly that I sense the painting is painting itself. I'm just along to transport the equipment. On other days, though, I've had a terrible time, with a struggle that drove me to distraction. Usually if I stay with the painting long enough, I can eventually pull the image together. But the going can be rough. However, these "difficult births" often become favorite children, for it seems as though my own willpower was the determining factor in bringing the painting to term.

Not all excursions yield a successful image for my efforts. Yet, if I were to judge an outing on the quality of the finished product I bring home, I'd really be cheating myself. It is the experience of working on location that is the real reward. Although I try to create good paintings, it is the process of painting that is the most important thing to me. The paintings, good or bad, are essentially byproducts of the plein air painting experience.

This is not to say I don't care about the artwork. Indeed, I do. I get tremendous pleasure from looking at completed work (that of mine and of other artists too). Nonetheless, good work is not created because it is the goal, but rather because it is the result of the creative process. Not only is it important to be engaged in the act of painting for the sake of producing artwork, but the act of painting is an enormously enriching experience in and of itself.

When we focus on the PROCESS, and constantly work to improve, we are much the better for it. To paraphrase Santayana, I'd suggest that those who rush to a mountaintop to see the view will not have the depth of understanding as those who fully appreciate the journey and value the rigors of the climb. In other words, the real value of painting and drawing lies in the act of creating the work, rather than the object created.

Painting is essentially a problem-solving activity. One mark requires another mark in response, and then another. Soon the artist is confronted with an abundance of choices. Where do I put the next mark? How dark or how light? The more time spent with each painting, the more crossroads are encountered. Which way to go? There are usually several correct choices, but you need to decide on one, even though the unchosen option has much merit.

The process also includes those moments when you determine that something needs to be done, though you're not sure what. This can be uncomfortable as you scratch your head in bewilderment. But as you engage your heart, stretch your mind, and bring forth a solution, you also generate a deep satisfaction.

Every challenge met makes you stronger. Obviously this is true of all art, as it is of life. When painting on location, the challenge just seems greater. Your senses are heightened and you are in tune with the environment. You see the subject, but you also hear it, smell it, and feel it. Consider these compelling words by van Gogh: "Look here, yes, you are right to paint in the open air; you should do it often."

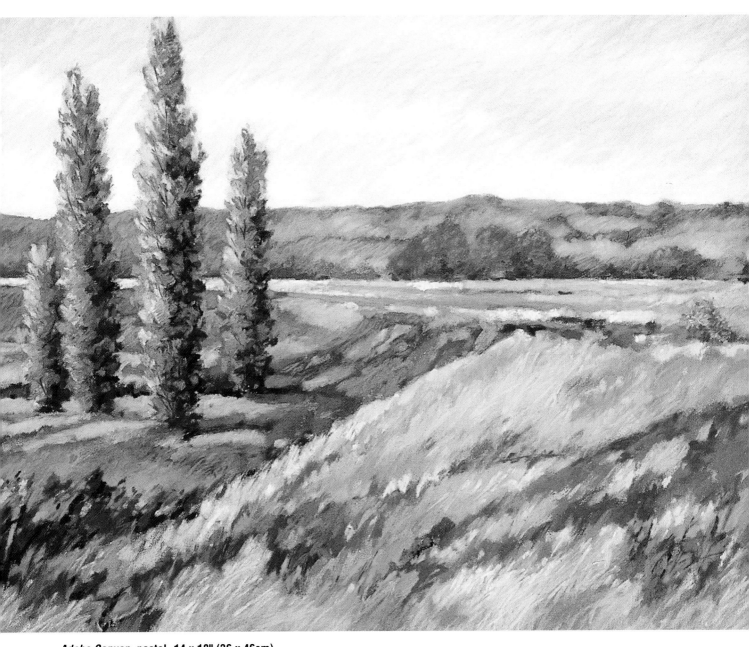

Adobe Canyon, pastel, 14 x 18" (36 x 46cm)

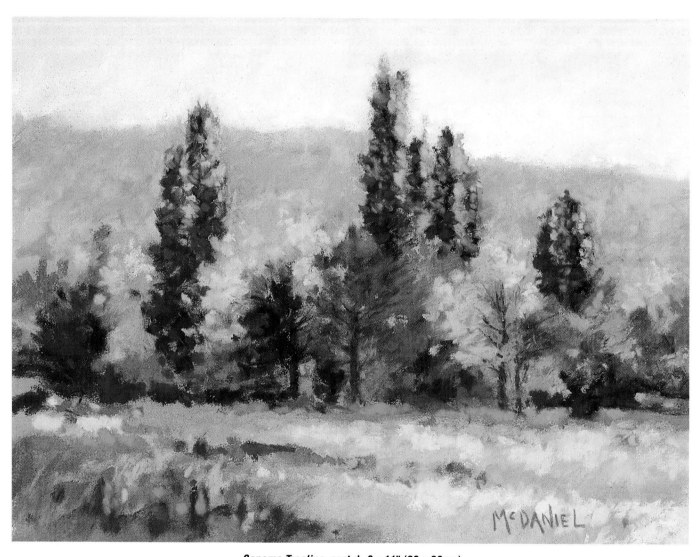

Sonoma Treeline, pastel, 8 x 11" (20 x 28cm)

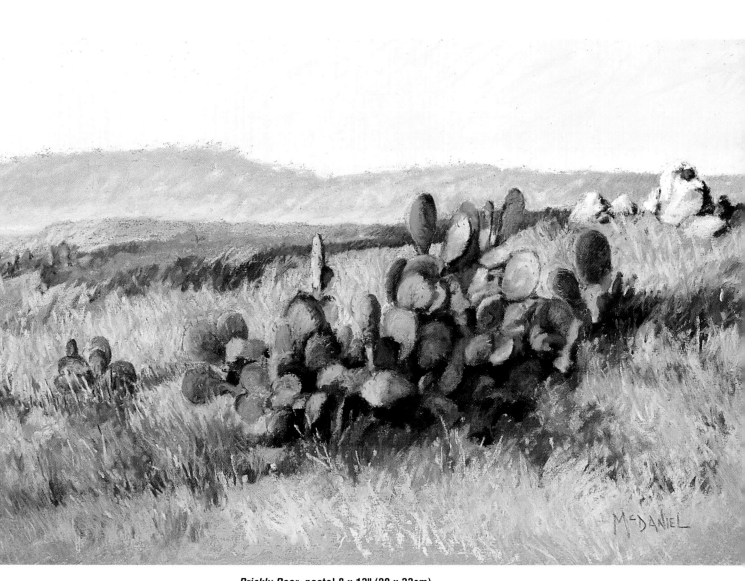

Prickly Pear, pastel 8 x 13" (20 x 33cm)

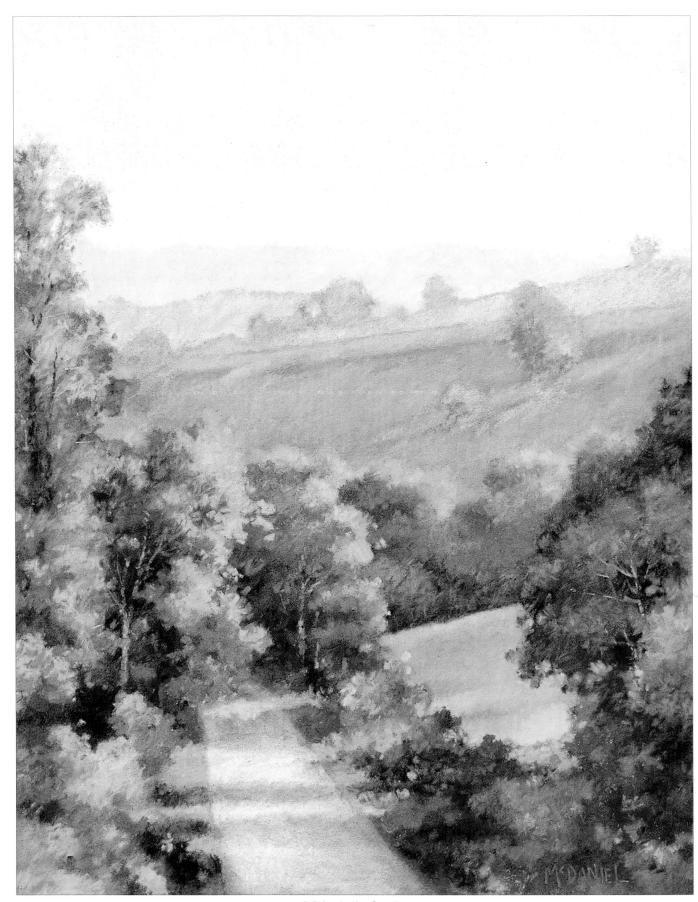

A Drive in the Country

About the Author

Richard McDaniel taught painting for 17 years at the Woodstock School of Art in Woodstock, New York, where he also served on the board of directors. He previously taught drawing at Connecticut State University and currently teaches landscape painting workshops nationwide.

A popular teacher and respected artist, Richard has juried international exhibitions for pastel societies in the United States and Canada. He is one of a handful of artists to be designated both a "Master Painter of the World" and a "Master Pastel Artist of the World" by *International Artist* magazine. He holds membership in a number of arts organizations and was awarded signature status in the Pastel Society of America, the Pastel Society of the West Coast, and the National Academy of Professional Plein Air Painters.

His work has been exhibited widely, including such prestigious venues as the Allied Artists of America, American Painters in Paris, National Academy of Design, New Britain Museum of American Art, Pastel Society of America and many more. Solo exhibitions have been held at Fairfield University, Lyman-Allen Museum, Redding Museum of Art & History, New York Conservatory for the Arts, University of Connecticut, and other institutions.

A native Californian, McDaniel studied painting at the Art Students League in New York and sculpture at San Diego State University before earning his MFA in Painting from the University of Notre Dame. Feature articles on his work have appeared in most of the major art publications. He is listed in *Who's Who in American Art*, and *Who's Who in the World*.

Richard's home and studio are in the Sonoma Valley wine country, where he lives with his wife Georgia.
Visit his website www.richardmcdaniel.com

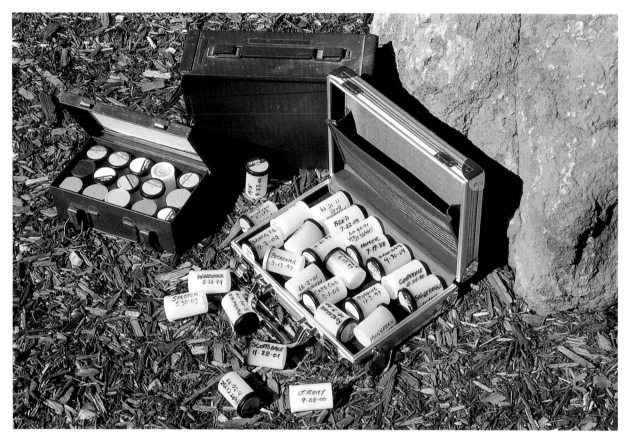

Here is my plein air collection. I have been collecting samples of "plein air" for quite some time. As a landscape painter and teacher I have visited many fascinating places over the years and I always enjoy returning home with these little souvenirs.